Dav

7/22/17

IMAGES
of America

TOWNS OF THE
SANDIA MOUNTAINS

FOR VIRGINIA —

I'LL LOOK INTO THAT SEDILLO ROAD
QUESTION & SEE WHAT I CAN FIND.

THANKS!

July 12, 2007

ON THE COVER: Albuquerque resident Jacob Stueckel relaxes on a rock pile in Tijeras Canyon, in the very early 1900s, watching his daughters on the rocks below. Today this tranquil scene is divided by the multiple lanes of Interstate 40 and old Route 66, and the juniper-stippled flanks of the mountains have become the eastern half of the town of Carnuel. (Courtesy Rick Holben.)

IMAGES
of America

TOWNS OF THE
SANDIA MOUNTAINS

Mike Smith

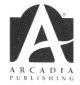

ARCADIA
PUBLISHING

Published by Arcadia Publishing
Charleston SC, Chicago IL, Portsmouth NH, San Francisco CA

Printed in the United States of America

Library of Congress Catalog Card Number: 2006926071

For all general information contact Arcadia Publishing at:
Telephone 843-853-2070
Fax 843-853-0044
E-mail sales@arcadiapublishing.com
For customer service and orders:
Toll-Free 1-888-313-2665

Visit us on the Internet at www.arcadiapublishing.com

To my parents, Farrell and Sandra, for bringing me to New Mexico.
To my brother, Jeff, for exploring it with me.
And to my wife, Camella, for making it the greatest place ever—
just by being here.

CONTENTS

ACKNOWLEDGMENTS

This book would not have been possible without the untiring help of the people of the Sandia Mountains, people who have made me like this little mountain range even more than I already did. I am so grateful to all of them.

I thank the collectors who met with me countless times, allowed me to scan images from their extensive collections, and became my friends.

I thank the locals and former locals who visited with me more often than I'm sure they had time for, let me pester them again and again for information, and shared with me their outstanding collections of historic family photos. These are the people who have made these towns great.

I thank all the terrific people who let me scan their amazing images, even if their pictures didn't end up being used in this volume.

I thank all those who let me interview them and benefit from their memories and research, talked with me on the phone, drove or walked around with me to point out landmarks, loaned me their books, fact-checked my writing, or played unbelievably great Western and ragtime songs for me on the piano.

I thank the many wonderful museums, archives, libraries, and associations that graciously allowed me to use their images in this book. I owe a special debt of gratitude to the East Mountain Historical Society and its members for all the work they did that I didn't have to. If ever an organization deserved some community money for a good museum, it would be them.

I thank the many Albuquerque and Sandia Mountains newspapers for helping to publicize my search for historic photos.

I thank my long-suffering editors at Arcadia Publishing, the staff of Exerplay, Inc. for the office space and encouragement, my parents and siblings—especially my dad—my parents-in-law, my lovely wife, and my perfect daughter.

I would also like to thank anyone I haven't met, who has relevant historic photos that don't appear in this book, and who e-mails me at antarcticsuburbs@yahoo.com about their inclusion in a possible follow-up. There's certainly much more to be told.

INTRODUCTION

Over 10 million years ago, much of what is now central New Mexico was a sprawling, corrugated panorama of low dirt hills and ragged plains—the vast remnants of a dried-away ocean. There were no Sandia Mountains to catch the day's last pinkening light, frame it in flanks and ridges, and hang it high on a granite wall. There was no Sandia Crest, no La Madera Canyon, and no Cibola National Forest. There was little around but open space and the wind across it, and one can imagine that the very land itself may have aspired to be more than what it was—to reach higher, and to stand taller.

Then, over millions of years, it did just that. In a gradual but epic geologic action, a massive, miles-long block of 1.7 billion-year-old metamorphic rock and 1.4 billion-year-old granite tilted up along a prominent fault line. The western side of that block—an over-20-mile-long mountain range with about 13 miles of almost vertical cliff face—rose up towering above today's Middle Rio Grande Valley. And the gently sloping top of the block, the mountains' eastern side, eventually became covered in thick desert forest.

In their long existence above ground, the Sandia Mountains have risen over the lives of prehistoric plants and animals and over smoke-billowing, lava-throwing volcanoes. They've been home to woolly mammoths and giant sloths and, if one believes the area's American Indian lore, to the gods themselves. The mythic figure of Changing Woman is said to have journeyed out of a world of only darkness, found the highest peak of the Sandias, and given birth there to twin gods that fought to allow the ancient peoples to journey out of blackness and into the world of warmth and sunshine.

If this legend has any truth to it, then that escape from darkness may have taken place around 12,000 years ago. Tools and animal bones discovered in a cave on the northern end of the mountains suggest that that may have been when the Sandias first saw human activity, most likely from prehistoric hunters who ventured into the mountains to hunt for now extinct giant mammals.

Over millennia, other peoples wandered into the area, began relying heavily on the mountains' wild plants, and later introduced small-scale agriculture, with patches of corn and beans springing up along Tijeras Creek, at the mountains' southern end. Agricultural settlements bloomed up from the bright soil near present-day Placitas, at the mountains' northern end, in the early 1300s—about when Ancestral Puebloans built villages near the modern day locales of Carnuel, Tijeras, San Antonio, and San Antonito, at least one of which was still occupied when the Spanish first rode within sight of the mountains in the early 1540s.

The Spanish came in search of new lands to conquer for the king of Spain, souls to save, mythical golden cities, slaves, and mineral wealth. Though disappointed not to find the area bristling with golden minarets, they took possession of the land anyway—both by physically taking it from the area's natives and by applying Spanish names to its features. The mountains' current name *Sandia*—or "watermelon"—came from them, for reasons historians are still trying to figure out, but very likely because residents of the nearby Sandia Pueblo grew a type of squash that some of the Spanish may have mistaken for watermelon.

Later, in 1706, after over a century-and-a-half of gradual colonization, the Spanish founded the tiny villa of Albuquerque, then spelled *Alburquerque*. Not long after that, they established satellite communities around the emerging city—including the settlement of Carnué (now known as Carnuel, at the mountains' southern extremity)—to protect Albuquerque residents and their animals from raiding bands of Navajos and Apaches. Other mountain towns—such as Tijeras, San Antonio, Cañoncito, and San Antonito—came into being not long afterward.

In 1846, following the Mexican-American War, New Mexico became a U.S. territory, and in 1880 the railroad came to Albuquerque. With those two events, the history of the Sandias changed forever yet again, as an influx of Anglo settlers trickled up the mountains to try their hands at mining, logging, and eking out a living. The U.S. Forest Service took up the management of over 100,000 acres of the mountains in 1908; the Civilian Conservation Corps set up a camp in the area known as Sandia Park and employed huge numbers of Depression-affected citizens to build campgrounds and hiking trails, from 1933 to 1941; and throughout the early 1900s, victims of the nation's tuberculosis epidemic poured up the mountains to newly established resorts, such as the Well Country Camp and Cedar Crest, in the hopes of finding health in the fresh air and dry climate.

This book is a story of the mountains, but it's also a story of the past, a reminder of our own impermanence, and a warning not to take our surroundings or our brief lifetimes for granted. On page 13 of this book, there is a 1908 image of a hooded woman and a bonnet-clad child, riding in a horse-drawn buggy through Tijeras Canyon—the canyon that divides the Sandias from the Manzano Mountains to the south. The road they're traveling on is dirt, and vacant except for them. Not a single house or power line or telephone pole or strip of pavement is anywhere in sight. The photograph was taken fewer than 100 years before the time of this writing, and yet, in the space of only one human lifetime, almost everything in the scene it depicts has changed. Shawls and bonnets have gone out of fashion, automobiles have replaced horses as transportation, and Tijeras Canyon is now the serpentine site of old Route 66, the multiple high-speed lanes of Interstate 40, and an ever-growing collection of homes and developments.

The people in that photograph had no idea the transformation their idyllic path would one day make, just as all of us today can only speculate on the futures of our own. In another 98 years, perhaps Tijeras Creek will have a dam built across it, Tijeras Canyon will be filled by Tijeras Reservoir, and hover cars will zip back and forth through the gray air above it. Or maybe the roads will lie radioactive, weedy, and abandoned, and the luckiest of us will hide out beneath them in concrete bunkers, eating dried algae, and eyeing our sisters. We don't know. We can't know, but if today's headlines and discoveries are any indication, the future may be incredibly different from the present, and the eight-lane freeways we traveled down in the early 2000s may seem astoundingly quaint in hindsight.

We may not be able to know the future, but we can value the present, and we can learn from the past. We can be humbled by the incomprehensible age of the land we live on, by the amount and significance of human history that's preceded us, and by the responsibilities of living our lives as examples for those yet to come, and of leaving a place worth coming to.

One

CARNUEL

Step into a car, and drive east out of Albuquerque on old Route 66. Head down the fast food Las Vegas of east Central Avenue, through the shabby foothills, and into Tijeras Canyon at the Sandia Mountains' southern end. Watch the canyon walls rise, the landscape change from suburbia to stony hills, and then, a few miles in, behold the town of Carnuel. In places, Carnuel seems like nothing more than scattered houses strewn and abandoned among the ruins of a wrecked mountain—an inhabited ghost town in the midst of a sloping boulder field. In others, it appears to be a thriving community, with a beautiful church and well-kept homes.

In its earliest incarnation, Carnuel was a defensive Spanish outpost with a walled plaza, set up by the people of Albuquerque in 1763—a "buffer zone"—a plucky though dangerously placed settlement that marauding American Indian tribes would have had to make it through before invading the city. Back then, Carnuel was called San Miguel de Laredo—or San Miguel de Carnué—or, just Carnué, a word most likely adapted from the Tiwa *Carna-aye*, meaning "badger place." Nineteen families were granted land for homes and farms, although eight years later, attacks by the area's Apaches caused residents to file a "Petition for Abandonment of Carnué." Soon after that, the town was vacated and torn down. By 1819, it was resettled, and it soon grew into a self-sustaining farming community, with the Spanish and Apaches intermarrying.

Carnuel has undergone many changes since then, including most of the surrounding land being taken from the area's land grant, a shift away from agriculture, an increase in development, and Route 66 and Interstate 40 being built right through its center.

"The freeway changed everything," says longtime Carnuel resident Pablo Herrera. "They ruined everything."

That is not to say that Carnuel doesn't still have an inimitable dusty desert charm, or that it doesn't have a distinct and worthwhile identity. It does—only now that identity has been sliced in half by a six-lane interstate, and its pieces aren't always easy to reassemble.

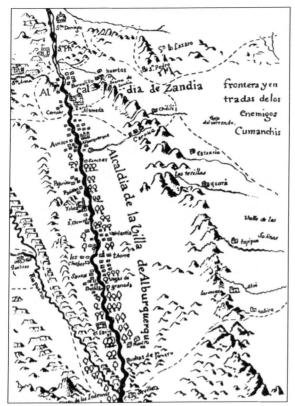

Bernardo de Miera y Pacheco—member of the 1776 Domínguez-Escalante expedition, explorers of more undocumented land than Lewis and Clark—was also one of the earliest people to make maps of today's American Southwest. This portion of his 1779 Map of the Interior of the Province of New Mexico shows Carnuel as Carnué, and in rough shape during a ragged attempt at resettlement. (Courtesy Museum of New Mexico.)

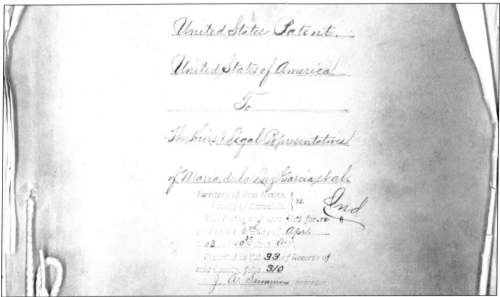

Under Spanish rule, residents of Carnuel and its environs were granted 90,000 acres of land, as the Cañon de Carnué land grant. The U.S. government, however, resurveyed the grant in 1901 and carved its acreage down to a mere 2,000. This is the cover of the 1903 grant patent, a document signed by Pres. Theodore Roosevelt. (Courtesy Richard Nieto and the Cañon de Carnué Land Grant Heirs Association.)

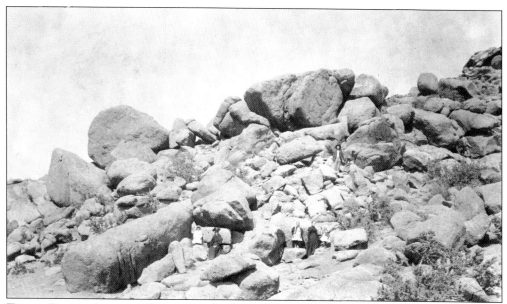

Tijeras Canyon, home of Carnuel, is also home to a rocky tangle of weathered boulders and drought-killed piñon trees, which passing travelers once referred to as "The Garden of the Gods"—and which Carnuel's residents once considered a garden for their goats. This photograph, taken in the early 1900s, is of an excursion to the garden by the Jacob Stueckel family. (Courtesy Rick Holben.)

Jacob Stueckel himself was born around 1866, and at the time of the 1900 and 1920 censuses lived in Albuquerque and worked as a day laborer and gardener. In this early 1900s photograph, Jacob watches his daughters play from atop a pointed rock pile in a part of Tijeras Canyon where today lays old Route 66, Interstate 40, and the newer, eastern half of Carnuel. (Courtesy Rick Holben.)

Originally called the Cañon de Carnué, the entire length of Tijeras Canyon has long been a popular getaway for the people of Albuquerque. This 1881 photograph, taken some distance behind Carnuel's present-day Monticello Drive, shows some of ways visitors have enjoyed the mountains in the past: as a place to gather wildflowers, exercise a dog, or fire off a pistol. (Courtesy Albuquerque Museum [AM], #1978-050-674.)

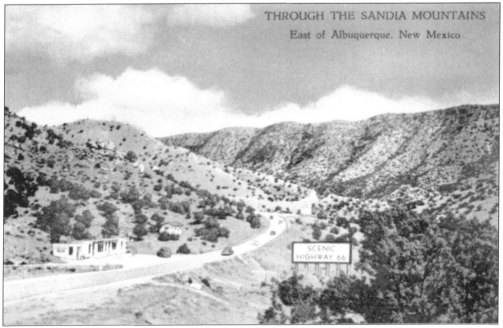

Although Tijeras Canyon remained a scenic place to pass through, the arrival of Route 66—America's "mother road"—in the 1920s introduced the canyon to people who found it an appealing place to stop and stay a while—or, as this 1950s postcard of Carnuel's Echo Canyon area shows—to maybe lease some land, start a grocery, and build a little house. (Courtesy Gary Francis.)

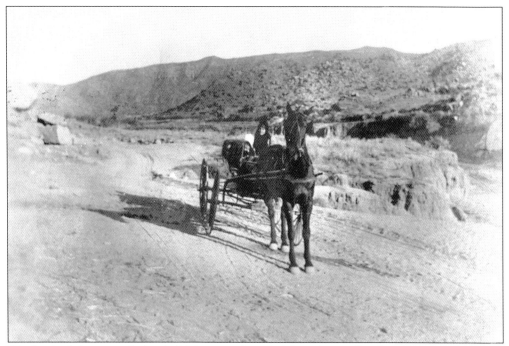

The back of this one-of-a-kind 1908 postcard reads, "Grandpa is *all* right," and tells of a trip to Santa Fe via Tijeras Canyon. Up until 1858 when the U.S. Army built the wagon road seen here, the only route through the canyon was a narrow horse trail. In the 1920s, the road was widened, paved, and made a part of Route 66. (Courtesy Rick Holben.)

This 1950s postcard shows Route 66 in Tijeras Canyon. Route 66 forever changed America, the West, New Mexico, Albuquerque, Tijeras Canyon, and Carnuel, which it divided. Ultimately, it even changed itself, as the amount of people it brought west became too much for it, and it was pushed aside by freeways. "It was a victim of its own success," notes Route 66 advocate Bob Audette. (Courtesy Gary Francis.)

13

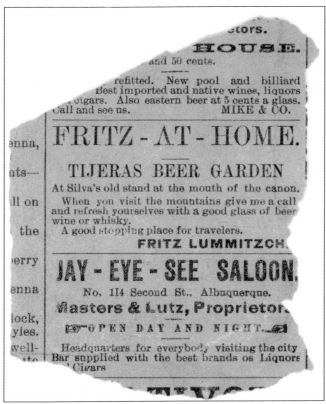

A prominent business around Carnuel is the Town and Country Feed Store. Business has been transacted at its location for well over a century, in a building constructed by an Italian stonecutter named Fernando Selva and originally run as a store, in the 1870s. By the early 1880s however, as this Albuquerque advertisement shows, businessman Fritz Lummitzch had turned it into a drinking establishment. (Courtesy Rick Holben.)

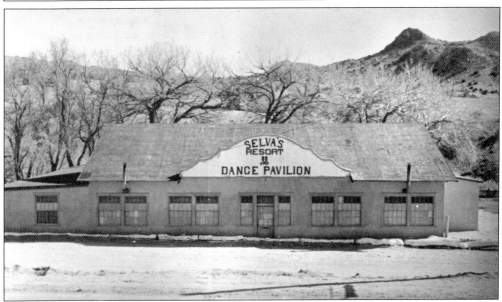

During Prohibition, Jim and Maggie Dooley arrived in Carnuel and established Selva's Dance Pavilion, a dancehall and speakeasy, at the feed store's future location. Jim Dooley was a freighter. Maggie was his gun-toting wife and may have worked a hidden still. Vivian Vance—later Ethel Mertz on TV's "I Love Lucy"—sang live at Selva's in the early 1930s. (Courtesy Center for Southwest Research [CSR], #000-289-0374.)

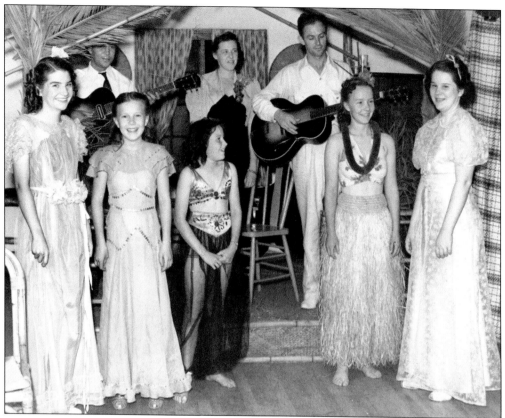

After Prohibition ended in 1933, so did Selva's. But by 1940, local KOB-TV celebrity Dick Bills had turned the building into the Paradise Valley Dude Ranch, a supper club with live music. Dick Bills's nephew, musician Glen Campbell, occasionally played Western swing there with the Sandia Mountain Boys. This photograph was taken there at a performance of the Dorothy Knight Dancers on June 8, 1940. (Courtesy Audrey and Orris Moseley.)

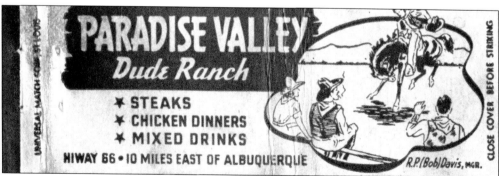

Longtime area residents have told of nights in Carnuel when music from the nearby Paradise Valley Dude Ranch would drift up the canyon and into their windows. The club eventually closed down, became a gym, became a campground, and then became the feed store. The building burnt down in 1996, but its foundation and parts of its walls were incorporated into its reconstruction. (Courtesy Alan Miller.)

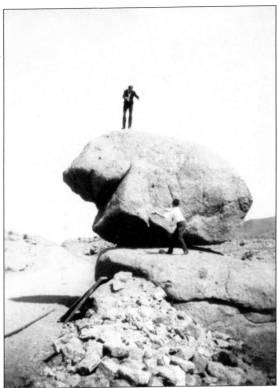

This is a c. 1925 photograph of Elephant Rock, a natural roadside attraction for Tijeras Canyon travelers and an important landmark for Carnuel. "When you passed that rock, you knew you were in Carnuel," says local resident Pablo Herrera. It was also called Teapot Rock and Balanced Rock, and locals tell of motorists hurrying past it out of it fear it might fall on them. (Courtesy Rick Holben.)

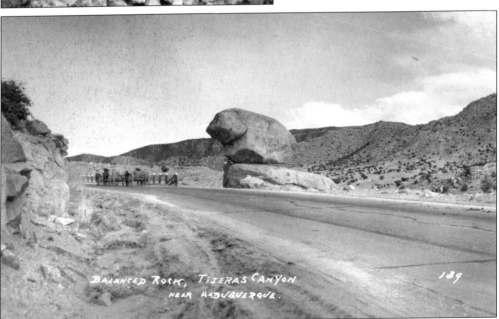

This 1940s postcard shows locals passing Elephant Rock, with supplies bought in Albuquerque. As late as 1950, families would load wagons with firewood, ride to Albuquerque, make coffee over bonfires near the future area of Albuquerque's bustling Juan Tabo Boulevard, and then go from house to house until all their wood was sold. Dogs from the mountains would often follow them all the way to town. (Courtesy Rick Holben.)

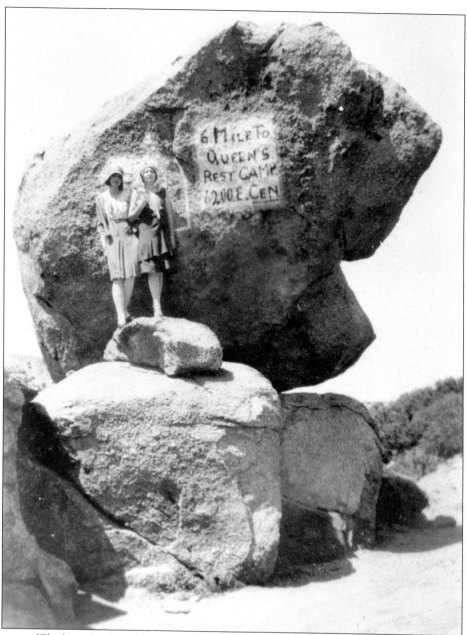

Because of Elephant Rock's high visibility, local businesses would often use its sides for advertising. Whether area teenagers were hanging out beneath it to smoke and talk, tourists were stopping by it to take a picture, or Dust Bowl refugees were driving past it on their way to California, all were sure to see the businesses that emblazoned it. The site of Queen's Rest Camp, indirectly advertised in this 1930s photograph, is now where Albuquerque's south San Pedro Boulevard meets Central Avenue—and no longer offers rest. Elephant Rock itself was jacked off its pedestal in the 1970s during freeway construction—even though it didn't end up being in the way of the interstate. Today Elephant Rock's base sits vacant, just east of the Town and Country Feed Store, on the south side of old Route 66. Next to the base lies the once-balanced rock, among weeds and tall grass, and telephone lines fill the sky above it. (Courtesy Bob Audette.)

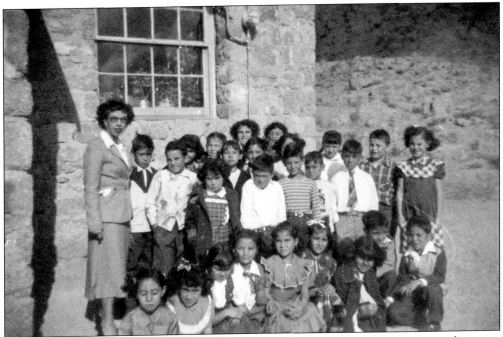

This 1953 photograph shows the two-room, rock schoolhouse that for many years stood open in Carnuel's Echo Canyon area. An archival film of Carnuel shows the school's students running around, treating the rocks behind the school as a natural playground. The school only taught the grades before high school, so a number of Carnuel's older residents never received more than an eighth-grade education. (Courtesy Irene El-Genk.)

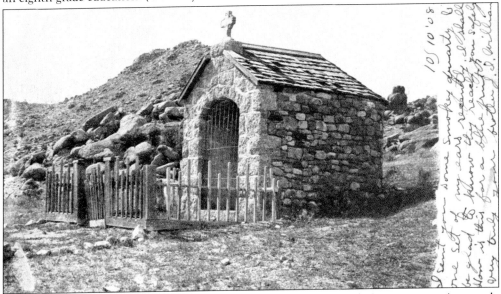

Showing both the freakishly rocky terrain of Carnuel and their Catholic community's strongly held religious convictions, this 1908 postcard was originally a blue-tinted cyanotype sent to Dora Williams of Lisbon, Ohio. Perhaps this little wayside chapel held an image of San Miguel de Laredo—St. Michael—Carnuel's patron saint, the patron saint of policemen, grocers and, more recently, paratroopers and radiologists. (Courtesy Rick Holben.)

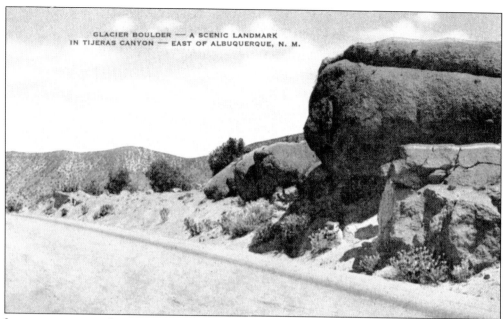

GLACIER BOULDER — A SCENIC LANDMARK
IN TIJERAS CANYON — EAST OF ALBUQUERQUE, N. M.

In a community with as many rocks as Carnuel has, and with Route 66 winding among them all, it was probably inevitable that some of those rocks would end up as local landmarks. Glacier Boulder, the rock on this 1950s postcard, never gained the popularity that nearby Elephant Rock did, yet Glacier Boulder remains intact and unmoved. (Courtesy Jamie Morewood Anderson.)

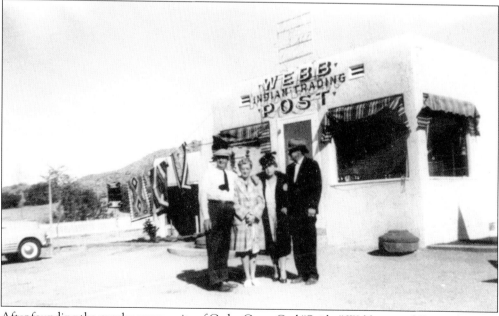

After founding the nearby community of Cedar Crest, Carl "Spider" Webb opened Carnuel's Webb Indian Trading Post. This early 1950s image shows Carl, his wife Emma, sister-in-law Mariah, and brother Sidney. In a 1983 interview, Carl said, "You know if I had my way about it, I'd stay about 30 years old and do nothing but sell Indian rugs. I sure did love the business." (Courtesy Martha and Timothy Walker.)

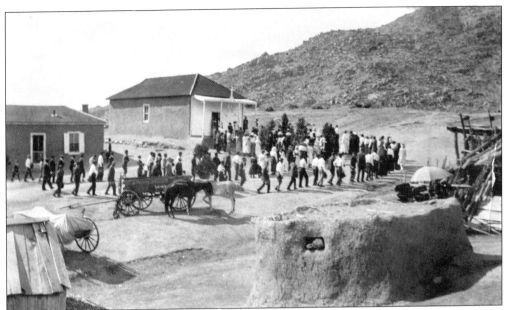

Carnuel has always had its commerce, its landmarks, and its faith. In the 1890s, two churches were built in Carnuel, including the San Miguel chapel shown in this photograph of a religious procession sometime before 1920. The privately owned San Miguel chapel was built by Carnuel resident Domingo Garcia as a home for the statue of San Miguel, Carnuel's patron saint. (Courtesy Rick Holben.)

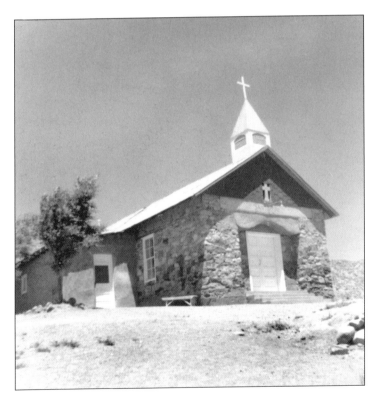

Carnuel's second church and the community's official church, Santo Niño, was built in 1898, on the town's western side. Pictured here in 1967, it was torn down in the late 1960s, although it was soon rebuilt as a larger, roomier building on the same land. The San Miguel chapel was razed around the same time, and its beloved statue was eventually given to Santo Niño. (Courtesy Mercie Chavez.)

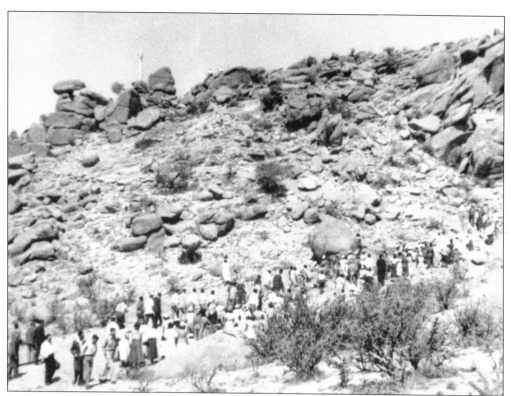

In 1932, area priest Father Libertini had a tall wooden cross built—*La Santísima Cruz*—on a rocky hilltop across from the Santo Niño church, as a reason for passers-by to stop and meditate. This photograph, perhaps as old as the 1930s, shows Santo Niño's patrons singing as they hike up the hill for their annual May 3 celebration. (Courtesy Mercie Chavez.)

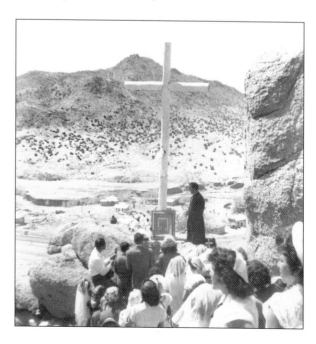

This photograph, perhaps from the 1940s, shows the congregation on the hilltop, with Fr. Luis Selmo praying near images of the holy cross and the Santo Niño—the Christ child. This tradition ended in the 1950s when a speeding car almost killed a line of worshippers as they crossed Route 66. Later the wooden cross burnt down and was replaced with one made of steel. (Courtesy Mercie Chavez and East Mountain Historical Society [EMHS].)

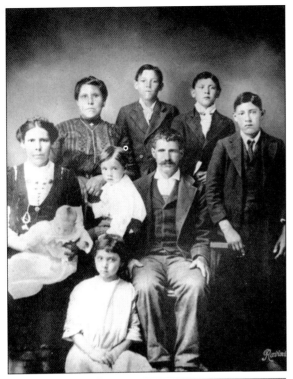

Carnuel has been a place of homes, businesses, and churches, but nothing has mattered quite as much in the story of Carnuel as its people. Like every human settlement, the heart of Carnuel—the thing that gives it life—is its people. Without people to build them, there would never have been churches. Without people to run them, there would never have been stores. Without people simply living their lives from day to day, there would never have been history. The above 1912 portrait shows the family of Carnuel's Cleto and Olympia Riboni, Cleto sporting a mustache and Olympia holding a baby. The Ribonis were well known locally for making goat cheese and moonshine. The photograph below shows Carnuel resident Miguel Jaramillo and an unidentified man during World War I. (Courtesy Dennis Lucero, above; Eloy Jaramillo, below.)

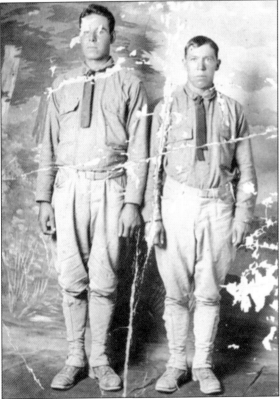

Two

TIJERAS

Let Carnuel fall past and grow smaller in the rear-view-mirror, and then watch it disappear. Continue east between the pale dirt and rocks of Tijeras Canyon, past lumpy hills scruffy with sagebrush and juniper, and beneath high and low cliffs unnaturally perpendicular to the road. Slip beneath the interstate up a long, round bend that was once sharp enough to earn the name of Dead Man's Curve. See the mountains ahead fill the windshield with a wide band of dusty green, and then, see Tijeras: a building here, a road there, some trees along a creek, two schools, a bar, an empty stretch, some homes, a hill. . . . See the plateau above the community, where a cement factory sits like a castle over a feudal hamlet, and see the mountains standing over the factory. Tijeras is a village—and an incorporated one—but it's a village in the mountains, and in the holes between roads and buildings, the mountains show through clearly.

In the northeast area of Tijeras known as Zamora are two thick-walled adobe homes that locals claim are 280 years old. Until that fact can be verified, however, written history has the European settlement of the village of Tijeras beginning in 1819, less than one year after Albuquerque's Spanish residents founded the community of San Antonio a bit farther north. Settlers there quickly discovered the limitations of San Antonio's water sources and soon petitioned the government for additional land near what is now called Tijeras Creek—land that has since become Tijeras.

In 1862, a brigade of Confederate soldiers made camp there, and one soldier noted that the settlement had evolved into "a sort of ranch," with a mill powered by a narrow stream. By 1880, that ranch had become the Sandias' second most populous community. Over time, and aided by its location at Route 66 and Interstate 40's junctions with State Highway 14, Tijeras has become the active crossroads for almost everyone east of Albuquerque, as well as the only Sandia town with traffic lights. Sooner or later, everyone passes through—and the smart ones stop to look around.

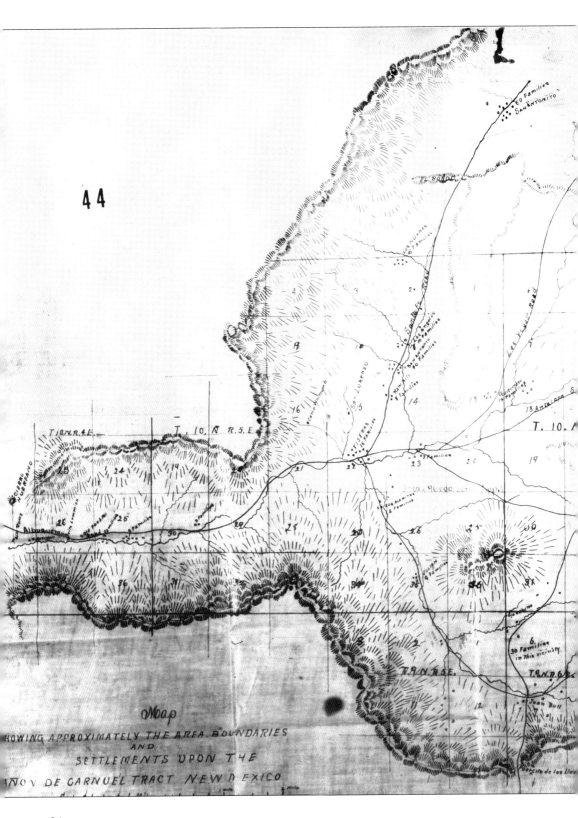

Map

SHOWING APPROXIMATELY THE AREA, BOUNDARIES
AND
SETTLEMENTS UPON THE

CAÑON DE CARNUEL TRACT, NEW MEXICO

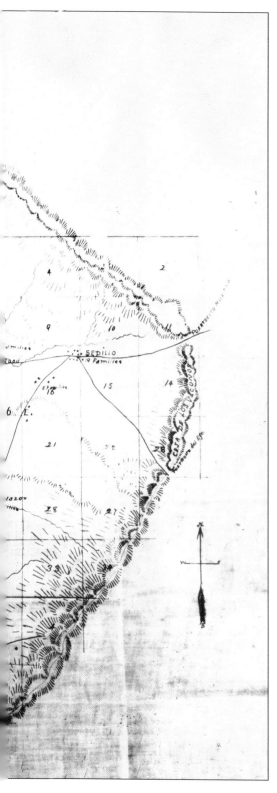

On this 1893 map of the original 90,000-acre Cañon de Carnué land grant, Tijeras can be found fairly near the center. The location—at the junction of vital area roads, and at the meeting place of the Sandia and Manzano Mountain ranges—allowed Tijeras to become the crossroads it is today. The word *Tijeras* is Spanish for "scissors," and looking at this or any other map of central New Mexico, one almost can't help but see the validity of the story claiming Tijeras's name is a metaphor for how two canyons—Tijeras and Cedro—or perhaps two roads cross like the blades of scissors, with the village of Tijeras at their center. Older Hispanic residents used to also refer to the town using Tijeras's singular form, La Tijera. (Courtesy Dennis Lucero.)

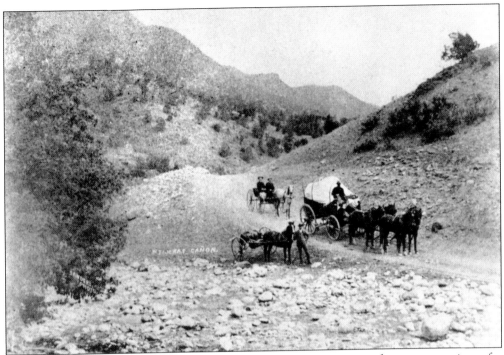

Nature's route to Tijeras, Tijeras Canyon, has always been important for transportation—for ancient Indians walking between pueblos, for gold-seeking forty-niners en route to California and, in 1868, for a 10-mile-long line of 7,000 Navajos newly freed from the confinement that followed their infamous Long Walk. This photograph shows the canyon around the early 1880s, probably behind today's Cañon de Carnué land grant meeting hall. (Courtesy Bob Sturgeon.)

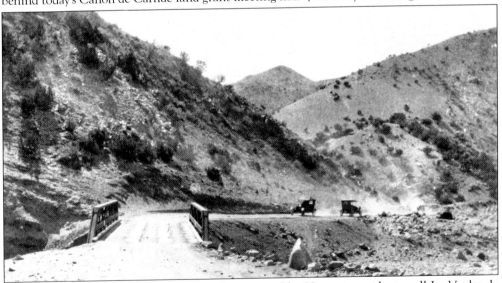

Not far east of Dead Man's Curve—or what some older Hispanic residents call La Vuelta de Cuchillas, "the turn of knives"—is a steep cliff facing the southern side of old Route 66. Near the cliff's base lie the concrete abutments of a vanished bridge, and half-evident traces of an original bend of Route 66. This photograph shows both bridge and road around the late 1920s. (Courtesy Rick Holben.)

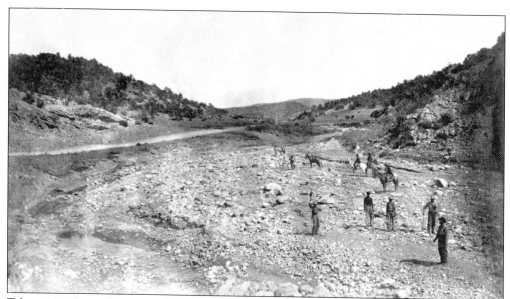

Taken in 1867 near the present-day Tijeras freeway exit, this may very well be the oldest photographic image of the Sandia Mountains. Famed Civil War photographer Alexander Gardner shot this image of the Kansas-Pacific Railroad Company surveying Tijeras Creek for a possible railway. A rail bed was later graded through Tijeras Canyon and beyond but was abandoned unfinished in 1903. (Courtesy Missouri Historical Society, #11438-1.)

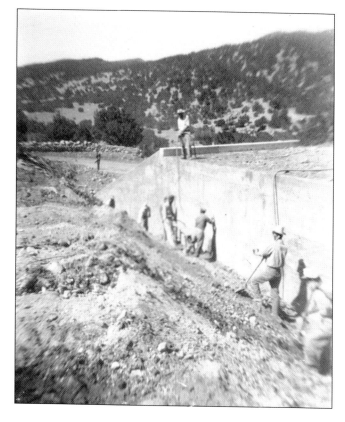

Route 66 originally wound through Santa Fe, until New Mexico governor Arthur Hannett lost a 1926 bid for reelection, blamed capital city politicians, and then avenged himself by having Route 66 rerouted through Tijeras Canyon, bypassing Santa Fe altogether. Work crews—as seen in this late-1920s photograph of Tijeras—toiled hard, despite frequent sabotage, believing they'd be fired when the new governor took office. (Courtesy Linda and Clarence Armenta.)

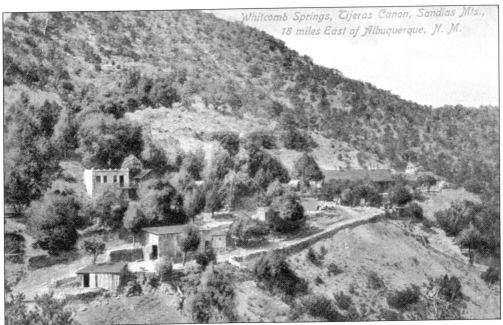

On a surprisingly lush terraced mountainside above the north side of Tijeras is a tucked-away spot once known as Whitcomb Springs. Over centuries, the property's prolific springs have attracted Ancestral Puebloan Indians, Apaches, stagecoach drivers, gold miners, and H. G. Whitcomb, a Union Civil War veteran from Kansas. In the early 1890s, Whitcomb came to New Mexico and began building the resort cabins shown on this 1910 postcard. (Courtesy Rick Holben.)

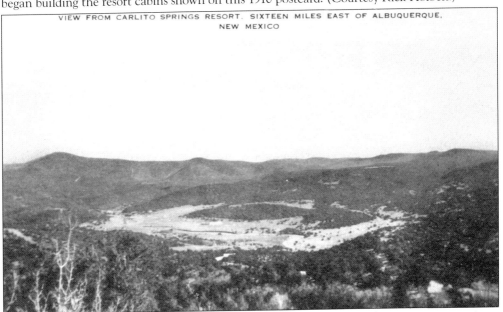

In 1930, Whitcomb Springs was purchased by Carl Magee, founder of the *Albuquerque Tribune* and an inventor of the parking meter. Renamed Carlito Springs, after Magee's deceased son, it became a resort, a boys' home, and a sanatorium. This 1930s postcard shows its view looking south: a panorama now divided by Interstate 40, hidden beneath Tijeras's cement factory, and carved away by the factory's strip mine. (Courtesy Rick Holben.)

Tijeras's most dominant feature must surely be its cement factory, built in the late 1950s and hunched like a ghost above the village. This April 1958 photograph shows a short-lived factory ironworkers' strike. "The ironworkers back then were a pretty big union, I know that," says Robert Mummey, a former mechanical supervisor for the plant. "What they were striking about, though, I can't say." (Courtesy Sandra Lee.)

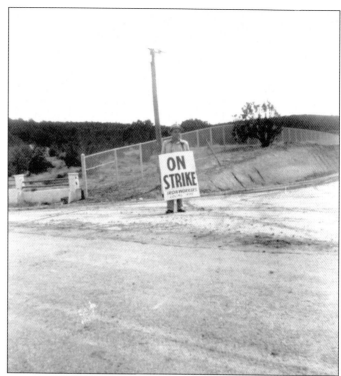

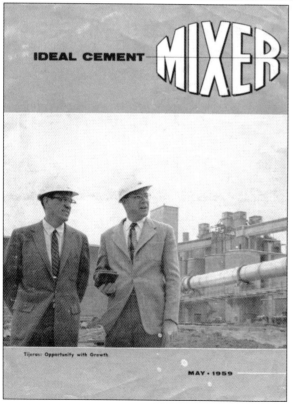

Just one month before the Tijeras cement factory's dedication, this May 1959 Ideal Cement Company magazine featured plant manager Robert Biggs and maintenance supervisor George Thompson on its cover and devoted several pages to the plant itself: its 131-foot-tall cement storage silos, its solid concrete light poles and roadways, and its unique dust collecting system that allows it to exist without an air-polluting smokestack. (Courtesy Robert Mummey.)

29

Just west of today's Tijeras freeway exit was once a rock gas station known as The Oasis. Its owner, Raymond Curtis, had served time in Colorado for bank fraud—perhaps unjustly—before coming to New Mexico to start over. In 1932, Curtis leased an empty building and opened The Oasis, for decades one of the only places around to buy gas and groceries. In 1967, a semi-truck hit Curtis's daughter Jan as she walked home across a rain-spattered Route 66. Jan fell into a six-month-long coma and only came out of the hospital five years later after The Oasis had been abandoned, possibly used as a whorehouse, and then leveled to make way for Interstate 40. The above postcard shows The Oasis in the 1930s, and the photograph below shows it c. 1940. (Courtesy Rick Holben, above; Justin Grabiel, below.)

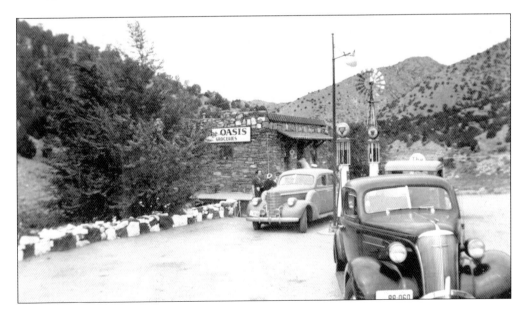

The people of Tijeras have made their village a place full of stories: stories of starting over, stories of tragedy, stories still being lived and written today. The young Tijeras residents in this photograph, c. 1904, surely had stories of their own, but most of those pictured are currently unidentified, excepting Luis Gonzales, in the center of the first row, and Jose Gonzales, holding the guitar. (Courtesy Irene Aragon.)

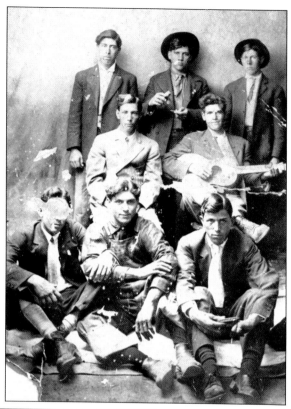

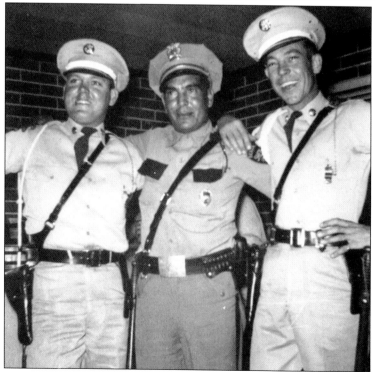

A photograph of Tom Herrera would be appropriate in almost any chapter of this book. From 1943 to 1973, he was the mountains' sole sheriff's deputy, patrolling hundreds of miles by himself and known wherever he went for his fairness, humor, and dedication. In this 1951 image, Herrera stands between two military policemen after breaking up a bar fight. (Courtesy Maria Herrera Dresser and EMHS.)

31

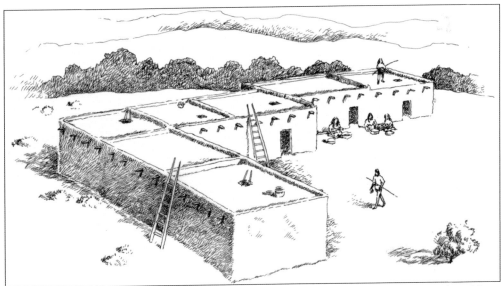

Tijeras's first inhabitants almost certainly did not call it Tijeras. They were Ancestral Puebloan Indians—attracted to the area by its springs, creeks, and game—who planted corn and built an over-200-room adobe settlement from 1313 to 1425, before abandoning the area due to lack of rain. This sketch shows what some of the pueblo's smaller buildings may have looked like. (Courtesy Dana Howlett and Cibola National Forest.)

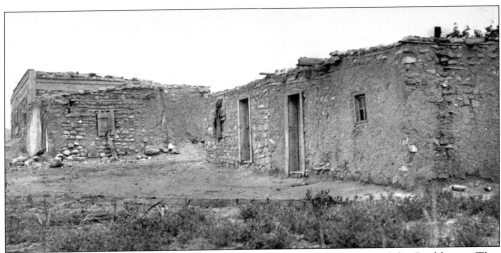

The Spanish also used adobe, although not with the puddled method of the Puebloans. This 1870 glass slide, labeled simply "Tejeras," may be of Primera Agua, a pre-1850 settlement on the village's south side. Primera Agua's name means "first water" and may come from a dependable area spring, or from the waters that reached settler John Davis's mill before flowing on to the rest of Tijeras. (Courtesy Rick Holben.)

This 1937 photograph shows a south-facing view of Tijeras's main area. Tijeras's old Catholic church sits on the left, and next to it is one of the village's two dancehalls, once popular among local teens and gamblers. The wall around the dancehall was built in the early 1800s, and its patrons would park their wagons inside it for protection against Apaches. (Courtesy CSR, #000-289-0003.)

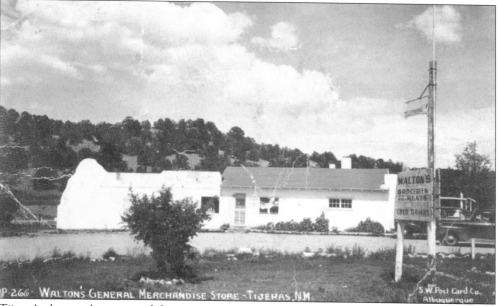

Tijeras's place at the crossroads has given it many of the Sandias' most vital services—stagecoach stops, schools, and, in the 1940s and 1950s, Walton's General Merchandise Store, owned and lived in by Oscar "Judge" and Edie Mae Walton. Anything anyone needed, Walton's had—or could order. "Rafel, I have the saddle here for you to see it," reads the back of this 1948 postcard. (Courtesy Gregorita Garcia.)

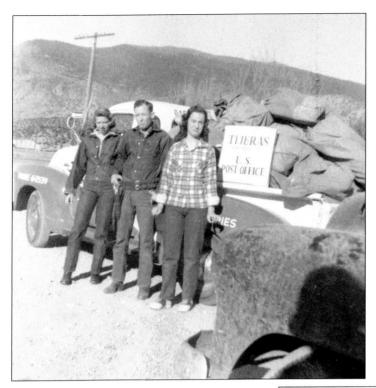

In 1947, the Waltons' store also became the Tijeras Post Office, helping area residents send and receive everything from Christmas cards to live deodorized skunks. In this 1953 photograph, Jackie Whitmore, Cleo Meek, and Sandra Walton strike a pose as they help with the mail. Twenty years later, the store's building would be destroyed when a Tijeras cement truck crashed clear through it late one night. (Courtesy Sandra Lee.)

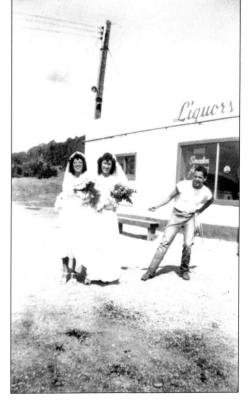

Another popular Tijeras business was La Luna Bar, owned by local man Pat Luna and run by him and his family. This photograph, taken August 4, 1947, shows Pat Luna's son Major playfully lassoing a local bride in front of the bar—a popular spot for parties and receptions. The bar itself is now gone, replaced by a stoplight and a patch of pavement. (Courtesy Major Luna.)

Not far west of the La Luna Bar was the Barlow Cafe, a small, short-lived restaurant. Leonard Barlow, the cafe's owner—on the right in this 1950s photograph with his wife, Estelle—is remembered as a quirky man who would often watch his patrons eat, and then give them advice such as, "Try to dab a little gravy on there, why not." (Courtesy Sandra Lee.)

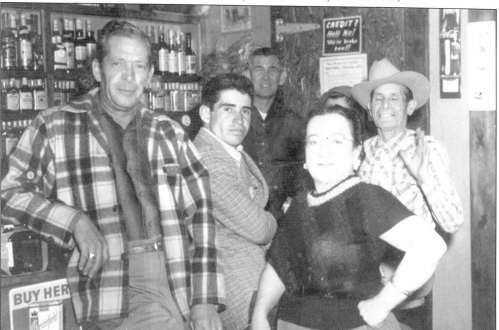

Perhaps Tijeras's most legendary and enduring business is Molly's Bar, founded around 1953 by Molly Simballa—a woman short in stature, but larger-than-life, famous for her generosity, though handy with a handgun, twice widowed, but quick to laugh, born in Italy, but at home in Tijeras. This mid-1960s photograph shows Molly's husband, Tony, standing back at the bar, Molly's patrons, and Molly. (Courtesy Romeo and Dianne DiLallo.)

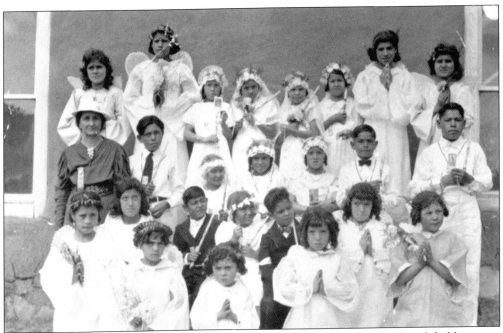

Tijeras is a place with a history of strong beliefs. Its old Santo Niño Catholic Church held services inside it from 1912 intermittently until the 1970s. This 1937 photograph shows Tijeras-area children there to celebrate their First Holy Communion, a Catholic rite of passage. Their catechism teacher, Juanita Muller, stands beside them. (Courtesy Florinda Crist and EMHS.)

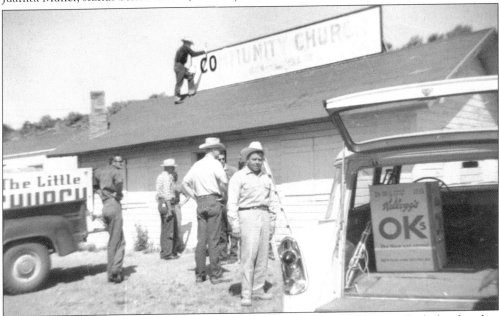

Not everyone in Tijeras is Catholic, however. One of the mountains' first non-Catholic churches was Tijeras's nondenominational Community Church of the Sandias, near the corner of Route 66 and State Highway 14. This photograph shows the church being put together in 1953, with prominent area resident Paul Grabiel painting the sign on the roof, and the Reverend Arthur Opperman looking at the camera. (Courtesy Justin Grabiel.)

Three

HOBBIES

From the uppermost Tijeras stoplight, veer left off old Route 66, and north onto the wide, perforated grayness of State Highway 14. Slip beneath the heavy shadow of the interstate, between files of poles and power lines, and up the steepening grass hills of northern Tijeras. Soon, look to the right—the east—and notice a bent road sign, and the remains of the former settlement of Ranchitos—or "little camps": heaps of rust and glass, the ragged black mouth of an abandoned mine, and the rubble outlines of vanished homes.

Then, look to the left—the west—at a Methodist church, and Penny Lane.

With dirt and gravel crunching beneath the car's tires, and perhaps The Beatles playing in the background, drive up Penny Lane among dusty pines and piñons, and when the road forks, go right—between the two weathered, nail-studded gateposts that mark the entrance to Hobbies. Keep left past tall and tasseled yellow grass growing up through the wooden frame of an ancient wagon; see lived-in trailers, live trees, dead trees, a plank-and-wire fence, the scarred black site of countless bonfires, a handmade mailbox labeled "Hobbie," a long cabin with a peaked roof, prickly pears growing among juniper roots, and two small cabins with their paint peeling and their porches sliding toward the ground.

These days, Hobbies is a rustic trailer park, but in 1918, as the "white plague" of tuberculosis devastated America, it was a place for TB victims to attempt to heal among fresh air and sunshine. Originally known as Kamp Killgloom, and later renamed the Well Country Camp, it was not only the first of the mountains' many TB resorts, but also the bringer of the earliest major migration of white settlers into the predominantly Hispanic Sandias.

By 1951, the camp was sold to Charlie and Shirley Hobbie, who fixed up the cabins and rechristened it Hobbie's Mountain Ranch—or just Hobbies on maps.

"Charlie fell in love with the mountain," Shirley Hobbie later recalled, and when the wind blows through, and the feral lilacs bloom, one can easily see why.

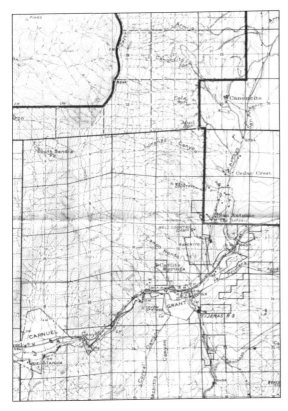

The Well Country Camp was established where it was because of the area's generally dry climate, fresh air, and temperate weather—all things highly recommended for tuberculosis victims at that time. The nearby Chanega Springs were also factors. This 1941 map of the Sandia Ranger District shows the site of the camp, although why another feature is also labeled "Well Country" is unknown. (Courtesy Rick Holben.)

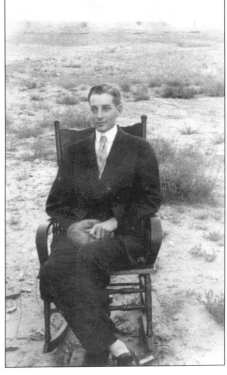

Sometime around 1909—not long before this photograph was taken—a Chicago physician told Larry Glasebrook, "Young man, you are 80 percent dead. You cannot live more than four months." Larry, optimistic and determined despite his tuberculosis, then proceeded to make his way west, trade his only possessions for two tents, homestead what would eventually become the Well Country Camp, and live for 12 years more. (Courtesy Penny Hobbie.)

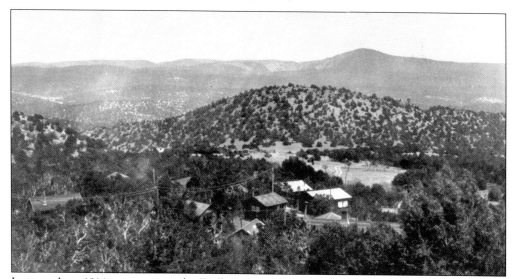

Find Out About Well Country Camp

The mountain resort for health-seekers of moderate means Just east of Albuquerque Rates reduced. Phone 490-W Write—

Arch Howard, Tijeras, N. M

The Well Country Camp was originally run "on the co-operative plan," but a few things changed after it sold to Albuquerque's Presbyterian Sanatorium following Larry Glasebrook's death in 1921. This 1920s advertisement to "health-seekers of moderate means" is a reminder that usually only people with money were able to check into resorts and sanatoriums, while often the poorest TB victims just stayed at home and died. (Courtesy Penny Hobbie.)

In its earliest 1914 incarnation, the Well Country Camp consisted of a couple of tents in Bear Canyon, on the west face of the Sandias. In subsequent summers, it moved to various other spots, before its ultimate site was filed as a homestead in 1918. As this 1925 photograph shows, private donations soon replaced the camp's tents with a dining hall, a bunkhouse, and eight one-room cottages. (Courtesy Penny Hobbie.)

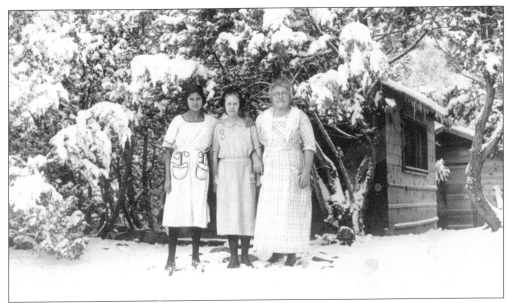

This photograph, taken on Thanksgiving of 1922, shows Christine Garcia, Josephine Fanning, and "Mrs. Lund," standing in the snow in front of a cabin. Lund was the camp's head cook, and the other two women may have been her helpers. Despite the snow on the ground, the camp's patients were probably still sleeping with their windows open, to better benefit from the mountains' fresh air. (Courtesy Penny Hobbie.)

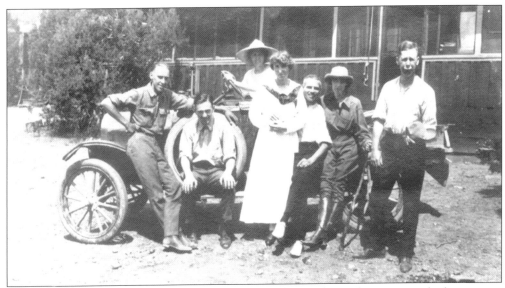

This 1920s photograph, of seven unknown health-seekers in front of a car, not only shows a way that the camp's health-seekers may have arrived there but also illustrates the gaunt appearances of many victims of tuberculosis. One of the main symptoms of TB is uncontrollable weight loss; others include high fevers, crippling chest pain, general weakness and fatigue, and long bouts of coughing up blood. (Courtesy Penny Hobbie.)

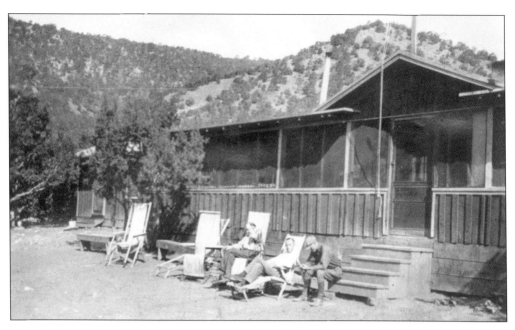

Many photographs of the Well Country Camp and many articles from its monthly journal, *The Herald of the Well Country*, suggest life at the resort was full of upbeat people having a great time—and it often was. However, the camp was always in the shadow of TB, and residents were unquestionably sick from the incurable disease. Jokes would elicit genuine laughter, but the laughs would always end with a cough, and the coughing would often end with a handkerchief soaked in blood. Cheeks would flush and temperatures would rise following the slightest exertions, and the will to do anything besides relax would vanish. Doctors at that time recommended nutritious food, clean mountain air, and days full of nothing but rest—rest in well-ventilated beds, and in chairs like the ones in these 1920s photographs. (Both courtesy Penny Hobbie.)

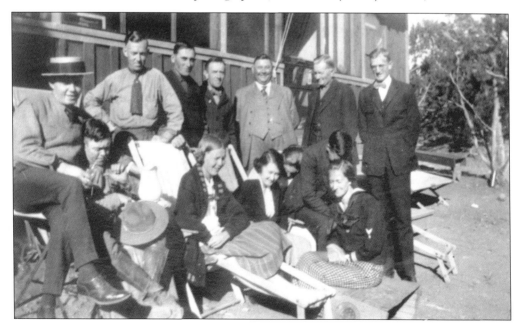

The December 17, 1922, issue of *The Herald of the Well Country* reported the following: "Bringing radio concerts to the Well Country Camp from St. Louis, Ft. Worth, Davenport, Iowa, and other notable points, was the achievement of M. Ralph Brown of the University of New Mexico. Mr. Brown, who has an excellent two-series receiving set, brought it out on Saturday and kept it in working order until his return the following Wednesday. A loudspeaker made the concerts available for all in camp, and several visitors from San Antonio and Tijeras, most of whom saw a radio set for the first time in their lives. The results were so satisfactory that the camp enthusiasts are now trying to raise sufficient funds for a permanent set for the camp and have secured in the neighborhood of $60." (Both courtesy Penny Hobbie.)

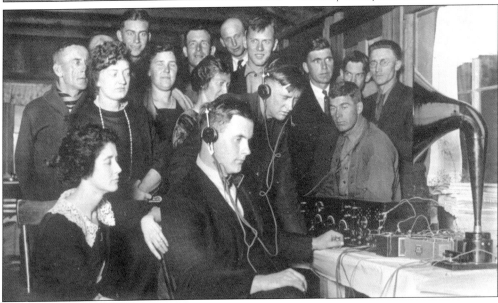

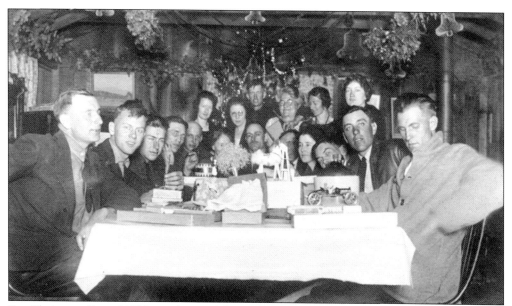

For Christmas Eve of 1922, residents of the Well Country Camp gathered in the camp's main building for a Christmas feast of three turkeys with all the trimmings, and an exchange of gifts. "Miss Lorene Higgins and Paul Stevens took two burros," reported *The Herald of the Well Country*, "and journeyed up to the rimrock where they secured a beautiful silver spruce for a Christmas tree." (Courtesy Penny Hobbie.)

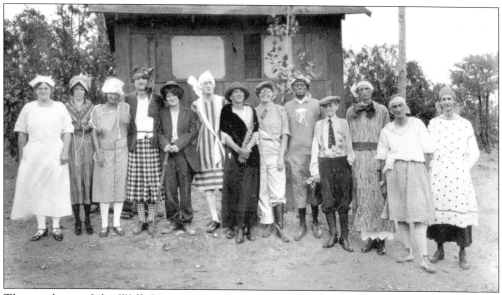

The residents of the Well Country Camp were notoriously good-humored and were always on the lookout for opportunities to set their troubles aside and be silly. This August 23, 1925, photograph of a "Tacky Party and Box Supper" caused area man Chris Jinzo to say, "If I had stumbled into that camp, I would have thought it was a mental home—not a TB place." (Courtesy Penny Hobbie.)

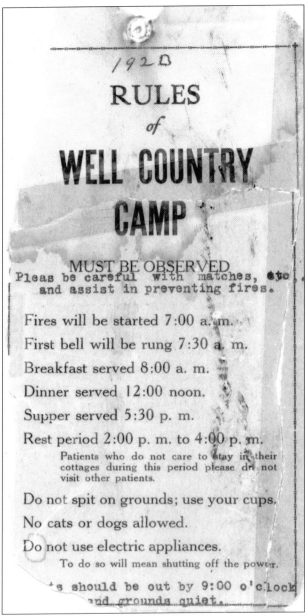

1920

RULES
of
WELL COUNTRY
CAMP

MUST BE OBSERVED

Pleas be careful with matches, etc.
and assist in preventing fires.

Fires will be started 7:00 a. m.

First bell will be rung 7:30 a. m.

Breakfast served 8:00 a. m.

Dinner served 12:00 noon.

Supper served 5:30 p. m.

Rest period 2:00 p. m. to 4:00 p. m.

Patients who do not care to stay in their cottages during this period please do not visit other patients.

Do not spit on grounds; use your cups.

No cats or dogs allowed.

Do not use electric appliances.

To do so will mean shutting off the power.

's should be out by 9:00 o'clock
and grounds quiet.

In her 1995 book *Tuberculosis*, Elaine Landau wrote, "Sanatorium life was characterized by the vast number of rules and regulations that patients were required to follow. Daily activities tended to be highly regimented: residents were told when to rise and when to sleep, what to eat, how to cover their mouths properly when coughing, how much time should be spent in the outdoor air, even how to bathe and brush their teeth. Above all, patients were encouraged to be optimistic about their condition. Under no circumstances was the topic of death to be discussed." Copies of this 1920 list of the Well Country Camp's rules most likely hung in all of the camp's many buildings. The rule about not spitting on the ground pertained to the fear that tuberculosis could be passed on through saliva, or through flies feeding on the patients' coughed-up phlegm. The rule about cats and dogs not being allowed was evidently often ignored, as many photographs of the camp show multiple dogs, and at least one cat. (Courtesy Penny Hobbie.)

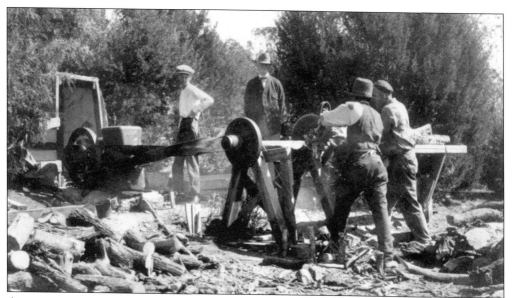

As patients improved, they were advised to work light exercise into their days of rest and recovery. One woman would walk from the camp down to what later became Route 66, and then back. Another man built a stone cabin, and others, like perhaps the men in this October 1922 photograph—Ford Newcomb, Mr. Ralph Moore, Jose Newcomb, and Lee Newcomb—sawed and stacked firewood. (Courtesy Penny Hobbie.)

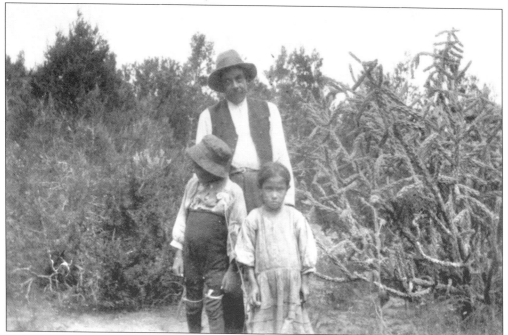

A handful of the Sandias' older residents recall their mothers cleaning the Well Country Camp's cabins and their fathers making repairs to the camp's equipment. Perhaps the people in this 1920s photograph were area locals who worked around the camp. And perhaps, after the camp was sold and sold and sold again, these three remained nearby, growing older, still making the mountains their homes. (Courtesy Penny Hobbie.)

When Charlie and Shirley Hobbie first arrived from New Jersey and bought the 44.78 acres that had once been the Well Country Camp, only seven of the camp's original buildings remained. The Hobbies restored the buildings, added plumbing, and rented them out to tourists. This 1950s photograph shows where the road to Hobbies, Penny Lane, meets State Highway 14, or what was then State Highway 10. (Courtesy Penny Hobbie.)

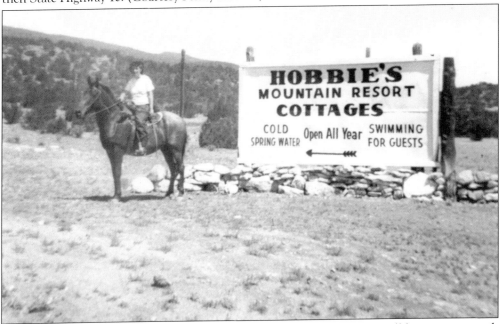

Shirley Hobbie—pictured here in 1952 at the base of Penny Lane—was well known as a good-natured curmudgeon, an irreverent jokester, and an incredibly tough woman. "You can't just let people walk all over you," she would say. "What do you gain? Nothing. Footprints." Shirley was known to defend herself with a shotgun, and she ran the place alone after her husband died in 1969. (Courtesy Penny Hobbie.)

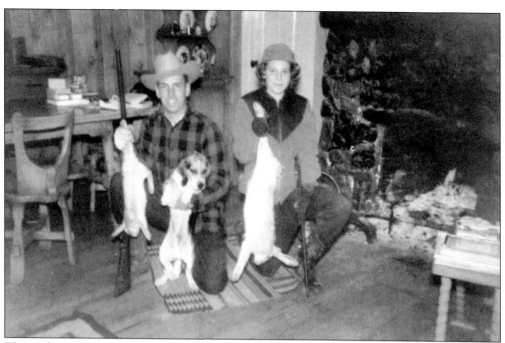

This early 1950s photograph shows Charlie Hobbie and June Stutsman after an area hunting trip. June was Shirley Hobbie's daughter from a previous marriage, but was raised by Charlie as if she were his own. Charlie worked for the Forest Service and was known to have incredible patience, never be in a hurry, and almost never get upset. His early death from leukemia was mourned by many. (Courtesy Penny Hobbie.)

When the Hobbies first saw the ranch in 1951, Shirley Hobbie could do little more than sit nauseated from morning sickness beneath a tree. Not long afterward, Shirley gave birth to their daughter, Penny Hobbie. Later the ranch's rocky access road—formerly Killgloom Avenue—was graded and became Penny Lane. This 1950s photograph shows Penny riding a pony and Charlie riding his horse, Red. (Courtesy Penny Hobbie.)

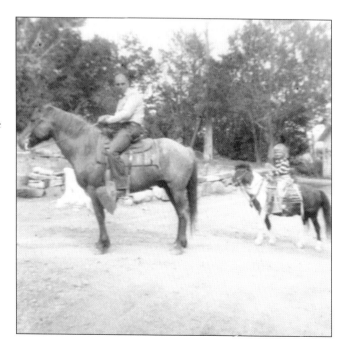

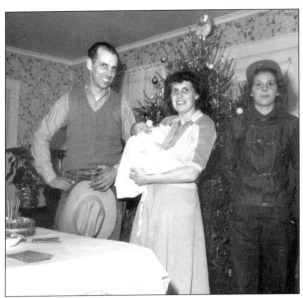

Longtime Sandia locals still talk about Hobbies: about the frigid reservoir that local kids could clean in exchange for masochistic swimming rights, about repairing the Hobbies' mechanical equipment, or about poaching on their property. What people usually remember most, however, are the Hobbies themselves: cleaning out a spring with Charlie, telling ribald jokes with Shirley, Christmas caroling in a sleigh with June, or combing the mountains with a search party for Penny after she didn't come home one night. The above 1951 image shows the entire Hobbie family shortly after Penny's birth. The 1950s shot below shows one of the Hobbies' infamous Friday night parties, at which Charlie would play accordion, Shirley would play washtub bass, anyone willing would play guitar, and everyone else would dance and sing. (Both courtesy Penny Hobbie.)

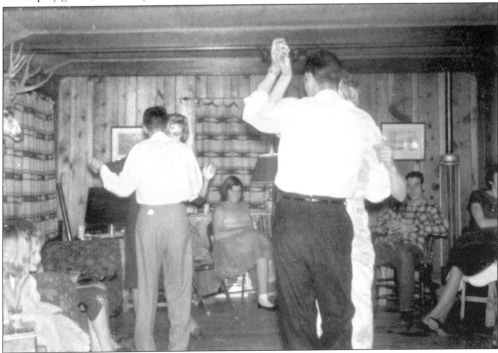

Four

SAN ANTONIO

Resume heading north along the gray asphalt boulevard of State Highway 14. Feel the road wind higher. See the hills grow taller. Observe the tilted wooded slopes of the Sandias' highest peaks as they suddenly fill the western horizon. Be on mountains, yet be beneath mountains; round a curve, and pass a sign that reads, "San Antonio de Padua, Est. 1819."

More commonly known as San Antonio, the town just entered could be compared to a sort of mountainside schoolyard, with cliques of trees, homes, and businesses all standing aloof from one another, and rocky green hills supervising everything from above.

In San Antonio, the present and the past are inseparable. Telephone poles shackled together by miles of wire trudge past weedy Puebloan ruins. A two-story office hides crumbling rock and adobe homes. A law firm sits near the bank of a centuries-old *acequia*, or irrigation ditch. And between the town's gas station and Burger Boy lies a graveyard full of twisted headstones dating back to the 1890s.

In 1819, 22 Albuquerque-area families arrived at "the ancient ruins of the pueblo called San Antonio" to establish a defensive outpost against the mountains' raiding tribes—just as other families were reestablishing the nearby village of Carnuel. The settlers quickly built homes and walled a plaza, planted crops and orchards, pastured livestock, and channeled San Antonio Creek into acequias. Over time, two other plazas and a church sprang up, and the town soon became the area's largest.

In its earliest days, San Antonio survived frequent Apache raids and attacks. Later it survived losing its grazing rights to the U.S. Forest Service. It survived epidemics of smallpox and diphtheria, drought, the construction and widening of State Highway 14 right through its center, and decades of being mistaken as part of nearby Cedar Crest.

And it survives still. Its church still rests beneath a towering stand of silver poplars that flash green in the summer and gold in the autumn. Its acequia still trickles down between buildings and gardens, its hills still rise above it, and its people still call it home.

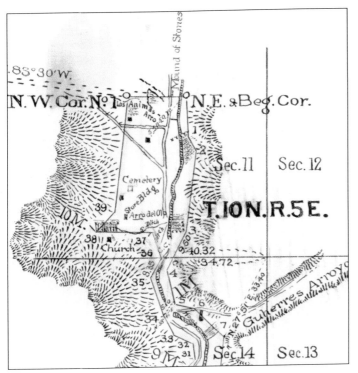

Established by the Spanish for the benefit of the landless poor, and as Albuquerque's protection against American Indians, the 90,000-acre Cañon de Carnué land grant was once the setting for most Sandia towns, including San Antonio. This 1903 map shows San Antonio at the grant's northern end, shortly after the grant was overwhelmingly reduced by the U.S. government. (Courtesy Richard Nieto and Cañon de Carnué Land Grant Heirs Association.)

St. Anthony of Padua—San Antonio's namesake—has inspired at least 36 New Mexico place names, more than any other Catholic saint. St. Anthony preached in Padua, Italy, in the early 1200s and is the patron saint of lost and stolen articles, the poor, American Indians, home, animals, and the harvest. This image of him is perhaps over 150 years old. (Courtesy Florinda Crist and EMHS.)

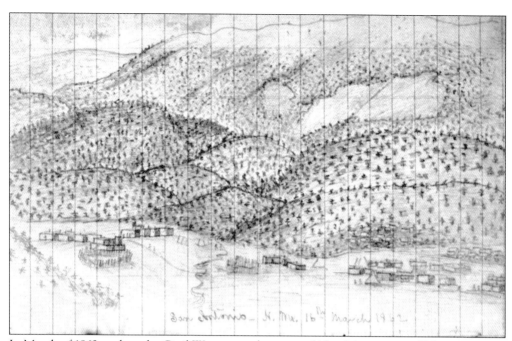

In March of 1862—when the Civil War was underway, and New Mexico was a U.S. territory—a Confederate brigade made camp for over a week in San Antonio. Soldier A.B. Peticolas made this sketch of the village in his journal. San Antonio's church is at the sketch's far left, marked with a cross, and the Confederates' tents and wagons are on the picture's right. (Courtesy Don Alberts.)

This photograph shows a corner of San Antonio around the early 1920s. The cattle pond has since drained and is now filled with the town's immediately noticeable poplar grove. The dirt road—State Highway 10—has since been paved, widened, and renamed State Highway 14. The long building in back served as a town dancehall and temporarily replaced the church when it burnt down in 1957. (Courtesy Chris Jinzo.)

Sometime around 1833, the villagers of San Antonio razed the walls of an ancient Puebloan structure, and in their place built a little rock and adobe church. That church quickly became the nucleus of San Antonio and for decades was the only place of worship in the entire Cañon de Carnué land grant. This 1920s photograph shows area priest Father Libertini in front of the church. (Courtesy Dennis Lucero.)

By 1943, when this photograph was taken, San Antonio's population had declined and not many families still lived around the church's plaza. In January 1957, the church caught fire and was destroyed. Its religious statues were rescued just in time, but its bell was stolen from the ashes. The church's cemetery and walls were bulldozed, and a larger church was built on its site. (Courtesy Penny Hobbie.)

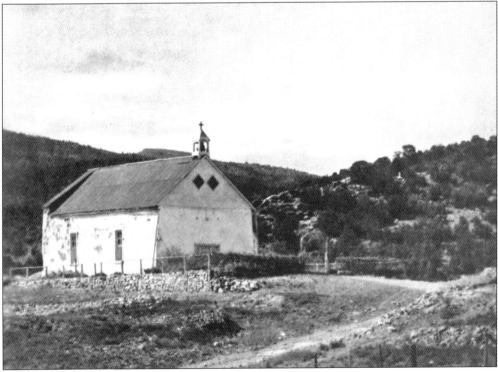

Every June, people from all around come for the fiesta at the San Antonio church. The central event of the fiesta is the traditional Matachines dance, which owes as much to American Indian dance steps as it does to European costumes and music. In this pre-1940s photograph, two unidentified dancers stand just left of area man Valentino Garcia. (Courtesy Dorela Perea and EMHS.)

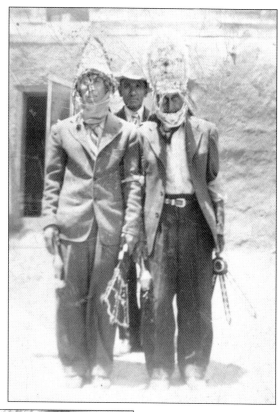

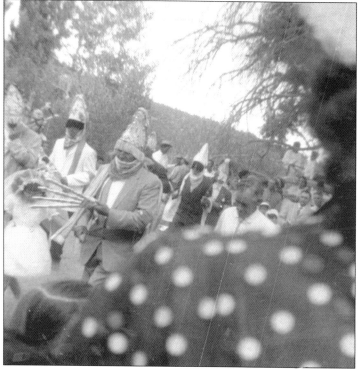

Long ago, it's been said, the villagers of San Antonio were under siege by Apache raiders when St. Anthony, dressed in blue, suddenly appeared and drove the Apaches away. To thank him, the villagers vowed to dance the Matachines dance every year from then on, in his honor. They were still dancing it in 1959, when this photograph was taken, and they're still dancing it today. (Courtesy Melba Scott.)

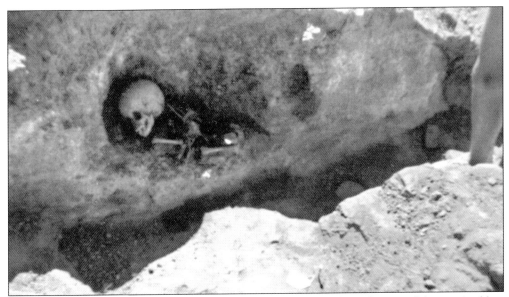

In the 1970s, State Highway 14 was more than doubled in width, and some of the area's oldest inhabitants came out for the occasion. In San Antonio, the formally buried remains of 30 Ancestral Puebloan Indians, and numerous dwellings—dating from the 1300s to the 1600s—turned up in the course of excavations performed scarcely one step ahead of the highway's expansion. (Courtesy Esperanza Gonzales, Victoria Gutierrez-Hefkin, and Gary Hefkin.)

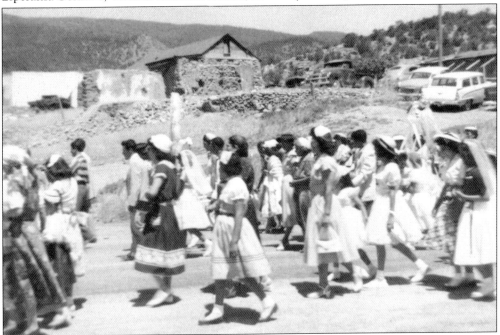

Until its expansion, State Highway 14 was a narrow, winding, two-lane road. This photograph shows a southbound procession walking along it in the late 1950s, past the roofless remains of San Antonio's church. Until the early 1950s, it was State Highway 10. And long before that, it was a rough track traveled by ox carts between Albuquerque and Santa Fe. (Courtesy Chris Jinzo and EMHS.)

Just north of the San Antonio church and its adjacent poplar grove stands a gray, two-story office building. But from 1927 to 1940, the San Antonio Grocery stood in that approximate spot, run by a man named Maximo Olguin. This photograph shows three children—Dora Sanchez, Ruth Jinzo, and Flaviano Sanchez—outside that store at the April 1935 wedding of locals Paul and Esther Jasler. (Courtesy Chris Jinzo.)

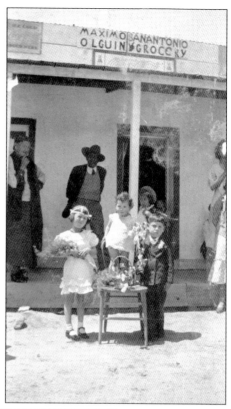

By 1820, San Antonio's settlers had established their second walled community plaza, complete with defensive holes for muskets. On the ruins of it in the 1880s, Italian-born entrepreneur Charles Campos built a store, dancehall, and a stone, still-enduring house—shown in this 1920s photograph behind locals Jesus Griego, two unidentified men, Tomas Sanchez, Eraclio Garcia, Claudio Sanchez, and Manuel Gonzales. (Courtesy Chris Jinzo and EMHS.)

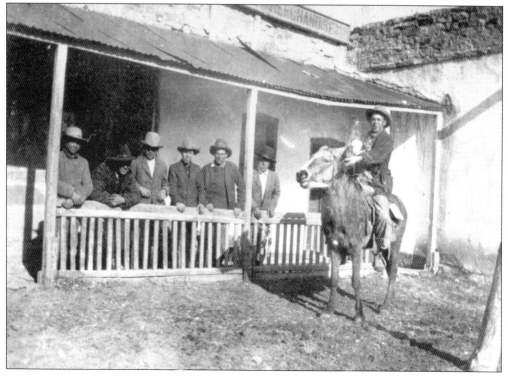

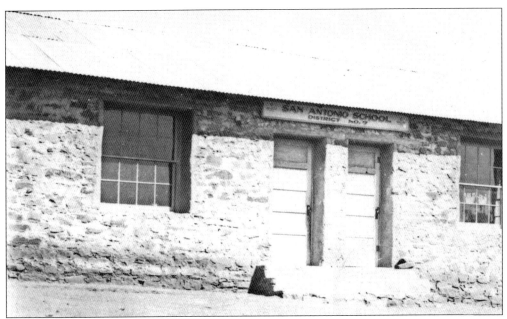

Across the highway from Charles Campos's old home, just north of the former site of the San Antonio Grocery, and on the same spot where a stuccoed law firm building sits now, was once the San Antonio school. From the 1920s (or maybe even earlier) to the 1940s, children from the first through the eighth grades would gather to learn in the little schoolhouse. To get to the school, kids who lived close by would walk, and others would ride in a wagon that served as a school bus. Pictured above is the school's exterior sometime in the 1940s; the photograph below shows students Carlota Garcia and Dennis Lucero performing a play inside the school in May 1949, perhaps the last year of the school's existence. (Courtesy Esperanza Gonzales, Victoria Gutierrez-Hefkin, and Gary Hefkin, above; Dennis Lucero, below.)

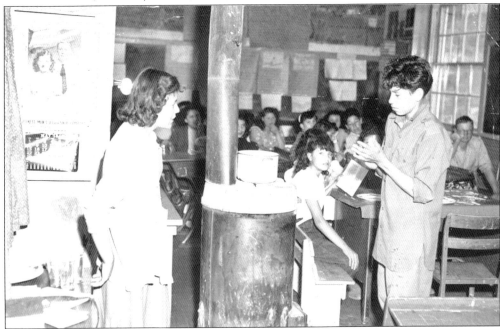

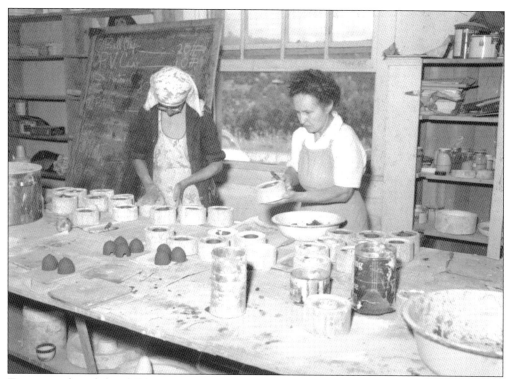

Time passed, and the children of San Antonio began attending school in nearby Tijeras instead, and the school's building became the home of the inaccurately named Cedar Crest Pottery Works. (Cedar Crest is farther north.) The business began in 1949 as a hobby of some of the area's Anglo women but soon partnered with experienced Hispanic locals and grew into a full-time business that became, at least for a while, well known among collectors of Southwestern pottery. These photographs show workers at the pottery works *c.* 1949. The business lasted into the 1950s but eventually closed down and became a sort of all purpose community building—a place for people to vote or to meet for a special occasion. Later it was torn down. (Courtesy New Mexico State Records Center and Archives [NMSRCA], #034962 and #034957.)

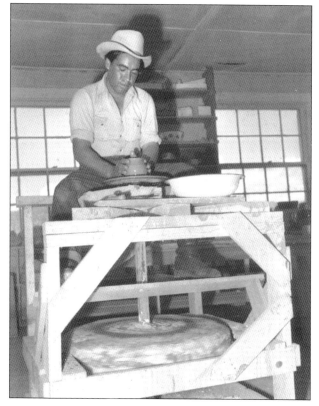

Just east of the San Antonio church is a rocky green hogback called La Centinela—"the sentinel"—atop of which Apaches once hid to ambush passing travelers. In the early 1860s, Apaches kidnapped local boy Quico "Kiko" Rael, disguised his light complexion with burnt yucca, and put him to work tending livestock. Quico was eventually ransomed, later married, and fathered Delfinio Rael, pictured in these early 1900s photographs. (Courtesy Dennis Lucero.)

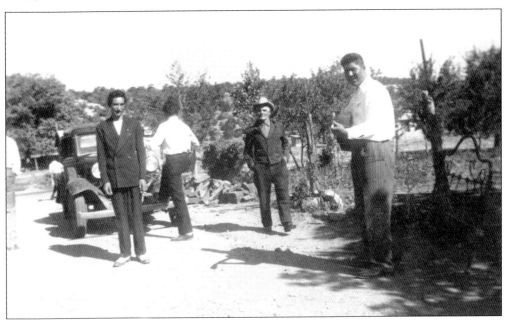

This June 9, 1927, east-facing image shows San Antonio fiesta-goers Andelecio Gonzales, Modesto Garcia, Juan Garcia, and Jacobo Armenta standing just east of the San Antonio church. Of Juan Garcia, former resident Dennis Lucero remembers, "He would shine up his boots and go to those fiestas." Juan also owned most of the nearby community of Rancho Colorado, behind the now abandoned Bella Vista restaurant. (Courtesy Linda and Clarence Armenta.)

Toward San Antonio's northernmost end, in an area once known as Upper Ranchitos and directly across from a realty building, is a grassy hill on which once sat a *morada*, built around 1865. The morada was a sort of exclusive chapel used by San Antonio's *Penitentes*—a Catholic sect known for whipping and otherwise punishing their bodies to make amends for their sins. (Courtesy Pam McCoy and Paul Black.)

In 1936, San Antonio's Penitentes became the subject of an international media frenzy—and even a movie—when Carl Taylor, a writer researching an article about them, was shot to death in his cabin. The Penitentes were suspected, but the crime also included robbery and was soon confessed by Taylor's teenage houseboy, Modesto Trujillo. This mid-1930s postcard shows Trujillo and his second cousin Ricardo Lovato. (Courtesy Dennis Lucero.)

59

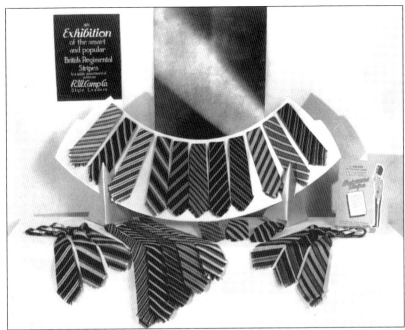

Just south of San Antonio's northern edge, on the highway's eastern side, sits the former home of the Apache Hand Loomed Products Company—a necktie factory founded in the late 1920s by Peter Peitavino, an Italian-born man who came to New Mexico with his wife, Bernice Peitavino, to try to recover from tuberculosis. Bernice died soon after arriving, but Peter learned to weave from area natives and began making neckties—ties seen in the above 1920s photograph, advertised somewhat inaccurately as "hand loomed, hand tailored at Cedar Crest, New Mexico," and valued highly enough to be sold at Saks Fifth Avenue in New York City. Peter eventually moved his business into Albuquerque, and the factory became the home seen alongside resident David Goens in the 1950s photo below. (Courtesy AM, #1978-151-092, above; Jerry Goens, below.)

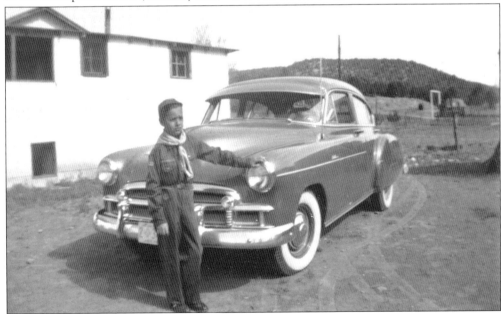

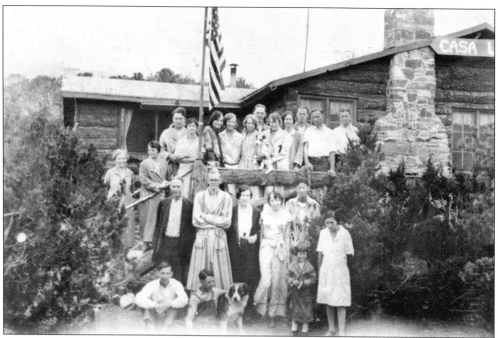

The northern boundary of San Antonio is roughly defined by what is known today as Casa Loma Road. Just across from the tie factory, and just south of Casa Loma Road, was once that road's namesake, Casa Loma Mountain Lodge—a tuberculosis resort founded in the 1920s. The resort was built and founded by Swedish husband and wife Paul and Vivian Worgren, but Oscar "Judge" and Edie Mae Walton—who would later own a store down in Tijeras—took over the place's lease around 1933. The 1930 postcard above shows Casa Loma's main lodge and dining hall. The 1937 photograph below shows a more general view. The name Casa Loma means "hill house" and was also applied to a string of summer homes built on property leased from the U.S. Forest Service along Casa Loma Road. (Courtesy Dennis Lucero, above; CSR, #000-289-0370, below.)

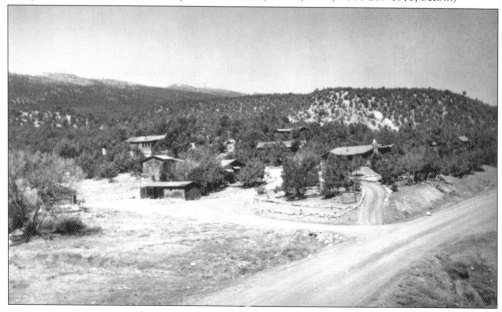

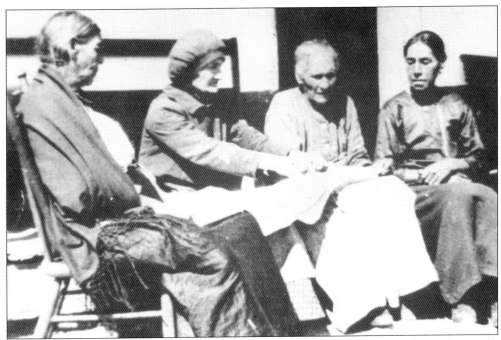

Ask a San Antonio local what it is about their town that they're the proudest of, and they might mention its springs, its acequia, or its fiestas. They might bring up the famous moonshine made from San Antonio Creek's water during Prohibition, the town's cameo in the 1940 film *The Grapes of Wrath*, or the triumphant 1998 standoff between shotgun-wielding locals and a bulldozer-driving developer. Most likely, however, they'll start talking about their grandparents: people like the brave and resourceful individuals in these early 1900s photographs. Pictured above are Mauricia Garcia Gonzales, Juanita Carpenter, Tonita Gonzales de Sanchez, and Jesusita Carabajal de Zamora, area women experienced in helping locals give birth. Below are Avanicio Gutierrez, Jose Gutierrez, Francisco Rael, Juan Olguin, Benito Gutierrez, Francisco Olguin, Manuel Griego, Elfigo Sanchez, and six unidentified women. (Both courtesy Chris Jinzo and EMHS.)

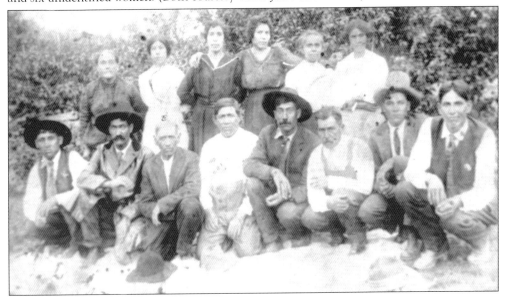

Five

CEDAR CREST

And now, the road winds upward, and fades into Cedar Crest: a sprawling mountainside community strung along both sides of a highway, set among high green desert hills, and riddled with commerce and parking lots. The 1920s cabins of its original Anglo settlement pass by quickly, hidden behind trees, while the town's more recent additions—including strip malls, a tire shop, restaurants, a bank, churches, a grocery store, a video store, a hardware store, and even an acupuncture clinic—are not quite as easy to miss.

For a small town, Cedar Crest is large. It contains multitudes. Within its vaguely defined boundaries lie the former Spanish settlements of El Rancho and Rancho Colorado, multiple former resort communities, and the undeniable and undying legacy of a man named Carl Webb.

Carl Webb was a hard-working, good-humored entrepreneur, born in Mississippi around 1900, and afflicted early in life with tuberculosis. At 18, Carl headed west in pursuit of a more healthful climate. He lived in California, lived in Albuquerque, stayed twice as a patient at the nearby Well Country Camp sanatorium, and—in 1921—acquired some land in the Sandias and built a cabin on it.

Soon afterward—inspired in part by his stays at the Well Country Camp—Carl borrowed some money, built a rental cabin, remodeled his original cabin to include a store, then built another cabin, and another, and another. Whenever he felt better, he built a cabin, and soon he had built his own resort—the Cedar Crest Resort—a place for tuberculosis victims to try to heal in the mountains' fresh air, and a place that, with the addition of a post office in 1925, would become a community.

Carl Webb came to the mountains with a life-threatening illness, yet founded a town. He was sometimes so sick that all he could do was just lie on his porch, covered in blankets, but when he could get up, he would work: standing alone beside an unfinished wall, holding a hammer or a saw, and casting a shadow that still falls over the community's every resident.

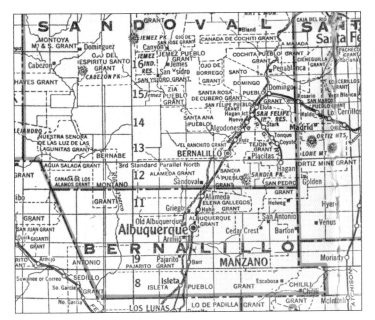

Published by the Hotchkiss Map Company, this mid-1920s oil-mining map correctly shows Cedar Crest's location due east of Albuquerque, but misleadingly labels San Antonito north of Cedar Crest as San Antonio—a common mistake on many area maps. Cedar Crest was given its name by its founder, Carl Webb, after the abundant "New Mexico cedars"—a.k.a. junipers—that cover the area's hills and ridges. (Courtesy Rick Holben.)

All around today's Forest Park subdivision entrance was once the Forest Park Guest Ranch, a TB resort where a Mr. Adams rented out cabins and horses. Forest Park also became a "rest and recreation facility" for the U.S. Air Force during World War II, as well as a series of restaurants. Today every building in this 1930s photograph is in ruins, and concealed by trees. (Courtesy CSR, #000-289-0371.)

Although there were other resorts in the Cedar Crest area—the Well Country Camp, Casa Loma, Forest Park, and others—only Cedar Crest lasted as a community, thanks in large part to the efforts of its founder, Carl B Webb, pictured above *c.* 1924 and below sometime in the 1920s. "The 'B' does not stand for anything," writes Carl Webb's son-in-law Timothy Walker. "Somebody just thought he should have an initial." Carl was the 10th of 10 children, and was known for being frugal, resourceful, fun-loving, and good-humored—a good friend and neighbor, and a hard worker. Carl also possessed skills as a water dowser and had an uncanny intuitive sense about the best places to plant things. (Both courtesy Martha Webb Walker and Timothy Walker.)

When Carl Webb first obtained his property from the government, the first thing he probably built was a tiny, low-ceilinged adobe shack, barely long enough for a bed, and with a rough wooden door. Carl most likely lived in the shack for about a year, sick and alone, while working on what soon became his house: the cabin in this 1920s photograph. (Courtesy Martha Webb Walker and Timothy Walker.)

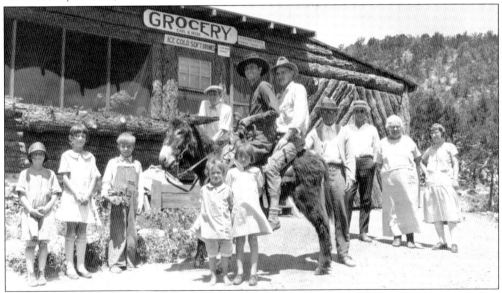

By 1925, Carl Webb's cabin had become the Webb Trading Post, as well as Cedar Crest's first post office, with Carl as its quirky postmaster and resident palm reader. This c. 1925 photograph shows Carl sitting on the back of his donkey, Doc, in front of the store and post office, among friends. The smallest sign on the building reads, "Señor Webb, Palmist." (Courtesy Martha Webb Walker and Timothy Walker.)

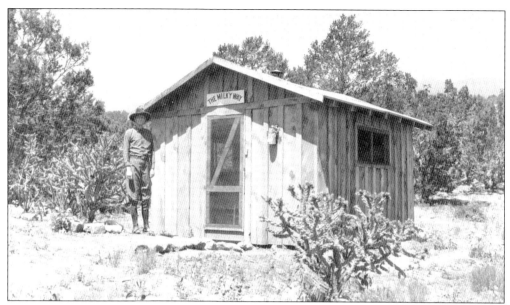

Most of Carl Webb's cabins were given names—including Loaf-a-Lot, La Cabana, and The Milky Way, pictured here in the 1920s. "I built this cabin all a lone [*sic*]," Carl wrote on the back of the image. "The man is on a milk diet." Such diets were considered miracle cures, and TB victims would sometimes ingest nothing but milk for up to a month. (Courtesy Martha Webb Walker and Timothy Walker.)

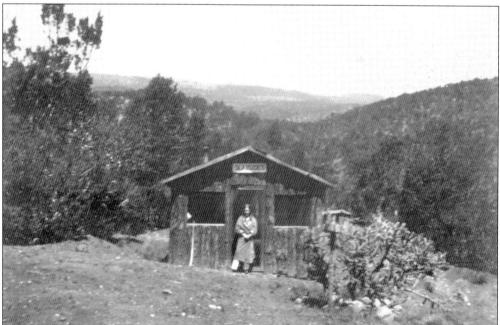

Another Cedar Crest cabin was Slabsides, named by Pulitzer Prize–winning author Conrad Richter and rented to him as a writing getaway for the summer of 1929. Many other known writers also spent time in early Cedar Crest, including Kyle S. Crichton, Neil M. Clark, Carl Norman Taylor, and a young Harvena "Vene" Richter—Conrad Richter's daughter, shown here in a 1929 photograph taken by her father. (Courtesy Harvena Richter.)

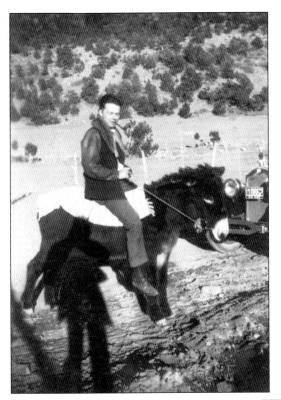

In the earliest days of Cedar Crest, when Carl Webb couldn't yet afford a horse, he would sometimes ride on the back of a milk cow he'd fitted with a saddle and bridle—occasionally with his pet rooster perched behind him. By 1925, however, when this photograph was taken of "Nate" (last name unknown), Carl had added multiple burros and horses to the resort's menagerie. (Courtesy Rick Holben.)

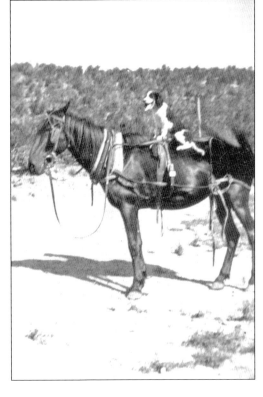

Sometimes, when visitors were feeling up to it, Carl Webb would lead his guests north, on horse-mounted trips along a trail to nearby Sandia Park. When the horses were not being used, however, Carl would teach his dogs how to ride them. "*All* his dogs rode horses," says Carl's daughter Martha Walker, and this 1920s photograph suggests that may have actually been the case. (Courtesy Martha Webb Walker and Timothy Walker.)

This 1920s image of Carl Webb's dress-clad donkey, Mary Jane, seems to fit well with Carl's lasting reputation as a man with "a great sense of pageantry." Mary Jane was brought home in the backseat of Carl's car when only a few days old, but sadly—Carl later recalled—"Some dadgum fool shot her," soon after this photograph was taken. (Courtesy Martha Webb Walker and Timothy Walker.)

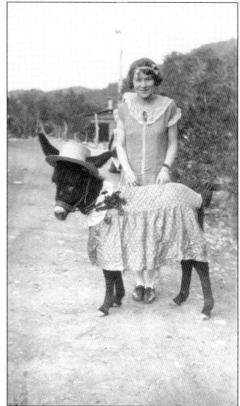

Carl Webb's main cabin can still be seen, on private property, by Mile Marker 2 on the western side of State Highway 14. At some point, perhaps in 1928, the Cedar Crest Post Office moved to a cabin directly across the road. Both cabins, and State Highway 10 between them, can be seen in this photograph of Carl during a 1930s winter. (Courtesy Martha Webb Walker and Timothy Walker.)

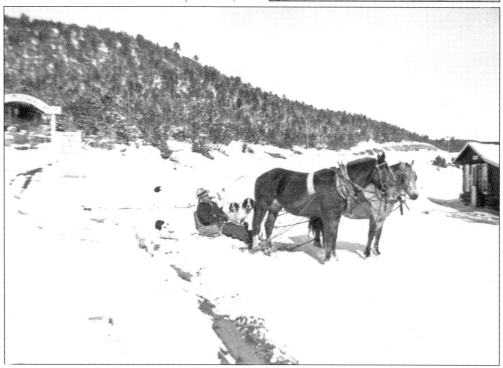

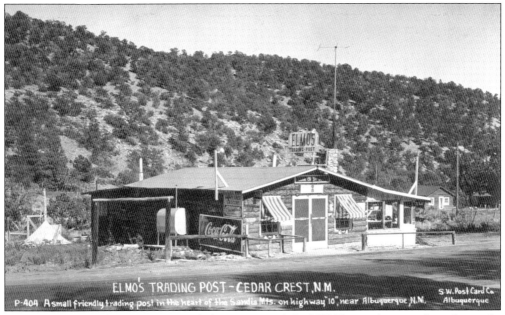

In the mid-1920s, three sisters visited the resort, and Carl Webb put them in the cabin right across from his, "Where I could keep an eye on 'em." The youngest sister was a kind, soft-spoken girl named Emma Fisher, whom Carl fell immediately in love with and soon proposed to. Later, as this late-1940s postcard shows, Emma's cabin served as Cedar Crest's store and post office. (Courtesy Nancy Tucker.)

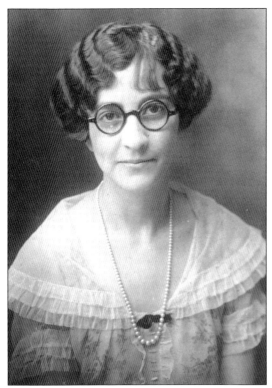

Pictured in this photograph c. 1927, Emma Webb was usually as quiet and shy in public as her husband Carl was talkative and outgoing, yet she was a strong woman who for years taught school in nearby San Antonito. She and Carl were unable to have children of their own but later in life adopted a little girl they named Martha. (Courtesy Martha Webb Walker and Timothy Walker.)

\mathscr{C}EDAR CREST RESORT

IN THE SANDIA MOUNTAINS

Sixty-seven Hundred Feet Above the Sea

CEDAR CREST, N. M.

CARL B. WEBB

RULES

We take it for granted you are nice folks with a proper sense of decency and appreciations of property.

Take care of your valuables we assume no responsibility.

Your day ends at 2:00 P.M.

All accomodations payable in advance.

In order for every one to enjoy our quiet and cool nights the management reserves the right to eject, without refund, any person or persons creating any objectionable disturbance.

The current is cut off at eleven o'clock each evening.

May you enjoy your visit with us and stop with us again.

we will

Author Kyle S. Crichton once wrote, "Too ill to make a living, Carl Webb built himself a business." And so he did. From a single adobe hovel, Cedar Crest grew into a prosperous resort, equipped with a gravity-powered water system and the electric power alluded to in the above 1920s rule sheet. Carl and Emma were soon able to afford the car pictured beside them in the 1920s photograph below. Emma would drive the car to teach school, making Carl almost insanely nervous about her safety. "He would have never made it without her," says their daughter Martha Walker. "She was what held him together." To soothe Carl's fears, Emma quit teaching, stopped driving, and began helping Carl out at the post office. (Courtesy Barbara McKnight, Pam McCoy, and Paul Black, above; Martha Webb Walker and Timothy Walker, below.)

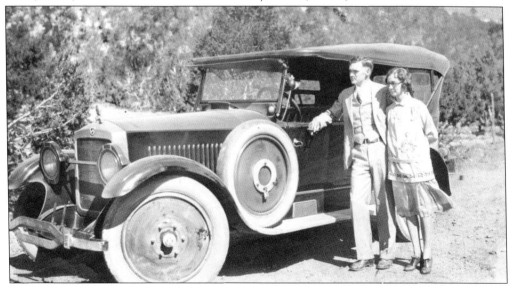

Carl Webb had a known love for animals, evidenced by the many dogs, burros, and horses photographed around his resort. However, he also came from a practically minded Mississippi farming family and sometimes viewed certain animals as commodities. At one point, Carl raised bees; at another he raised minks and foxes in pens behind his cabins, for their fur. "See our silver fox and Yukon mink farm," his business cards read, and the farm can still be seen today—rusted and in pieces. In the early 1940s photograph above, Dick Clark—son of author Neil M. Clark who later bought Carl Webb's main cabin—pretends, at Carl's suggestion, to be attacked by a dead fox. The 1930s photograph below, captioned by Emma Webb, shows "Daddy and a mink." (Courtesy Dick Clark, above; Martha Webb Walker and Timothy Walker, below.)

In an article about Carl Webb in the December 15, 1927, issue of the *New Mexico State Tribune*, writer Kyle S. Crichton wrote that Carl "spent about $500 building a fish pond, which Dame Nature in the shape of this year's spring flood washed out. . . . It's a great life, life in the mountains. In addition, he has a public camp ground with a public swimming place and plenty of water, and a playground for the children, with swings and see-saws and everything else necessary." The dam that formed Carl's short-lived fish pond appears in the above mid-1920s photograph, with the denuded pasture where Carl grazed his horses in the background. Carl's handmade playground appears in the 1920s image below, perhaps the very first playground in Cedar Crest. (Both courtesy Martha Webb Walker and Timothy Walker.)

For a Cool Night's Sleep Drive Two Miles off Highway 66

WHEN YOU SEE THIS ENTRANCE

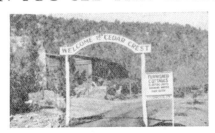

STOP

AT

CEDAR CREST RESORT

In the Cool Sandia Mountains—Secluded
Cottages Among the Trees—Electric Lights
Cold Spring Water — New Inner Spring
Mattresses — Completely Equipped Kit-
chens — Meals if Desired — Reasonable.
Linens and Blankets Included

RATES

$2.00 per cottage and up

WATCH FOR OUR SIGNS

Turn North on State Highway No. 10 (Sandia Rim Drive) at
Junction 16 Miles East of Albuquerque

CARL B. WEBB, Prop.

In 1928, Carl Webb resigned from his position as Cedar Crest's postmaster. Around 1936, he met writer Neil M. Clark, who would subsequently buy his cabin and some of his land. And in the late 1940s, in search of something new, he and Emma divided and sold the resort, moved down the road into Tijeras Canyon, and opened the Webb Indian Trading Post in Carnuel. There he and Emma adopted their little girl, and Carl applied himself to becoming an expert in handwoven American Indian rugs. The Webb family sold the trading post around 1955, and moved to Cañon City, Colorado, where Carl worked as a meat inspector, built a house, and farmed. From 1974 to 1983, the Webbs lived in five different states. In 1983, Emma died, after which Carl moved to Pennsylvania to live with his daughter. He died there in his sleep in 1992, several decades after being diagnosed with what could have been a rapidly fatal case of TB. Cedar Crest, however—the little town he helped found—lives on. (Courtesy David and Sandy Ligon.)

Six

CAÑONCITO

The northbound highway angles upward, and Cedar Crest seems to slide past and down it. Grass-filled arroyos run alongside the road, run to meet the road, and then disappear beneath it. The dense tilting green of the Sandias' wide, wooded slopes fills the western horizon. A long cliff-faced ridge hangs suddenly over the view to the east, and the roughhewn Sandia Mountain Hostel reclines near its base. Directly across from the hostel is Cañoncito Road: turn left on it, and follow it up through Lorenzo Canyon into the heart of a mountain village.

Set against a backdrop of close-growing pine-covered peaks and ridges, Cañoncito is often considered everything between the towns of Cedar Crest and San Antonito, often considered only the area around Cañoncito's cemetery and Catholic church, and often not considered at all, by those who mistake it as nothing more than part of Cedar Crest.

When the nearby Spanish community of San Antonio was founded in 1819, not all its residents were content to remain there together. This is evidenced by a petition for land filed in 1826 that referred to the site of Cañoncito as El Cañoncito de Nuanes—"the little canyon of Nuanes"—and stated that, at that time, the area was uninhabited. One person who received land around San Antonio in 1819 was a man named Juan Nuanes, and at least one ethnohistorian has suggested that Nuanes was not only Cañoncito's first European settler, but also perhaps the first to flee the settlement following an Apache attack.

Sometime in the late 1850s, however, members of Juan's family returned to El Cañoncito de Nuanes—joined by 28 families more—and over time, the tiny farming and woodcutting settlement gained two short-lived dancehalls, a church, a gypsum mine, a flagstone quarry, and lost the bulk of its name.

Around World War II, former resident Dennis Lucero recalls, "In winter, when it was real quiet, you could stand outside and hear the whistle blow from the train yards in Albuquerque."

Today one hears the rush of cars instead, but also, the wind in the trees.

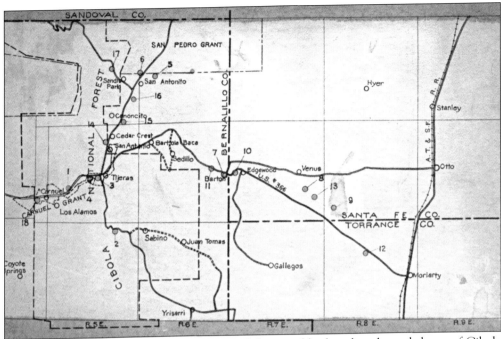

Cañoncito's picturesque setting, at the foot of the pine-blanketed peaks and slopes of Cibola National Forest, is shown on the above 1937 Rural Electrification Administration map and was no doubt selected for its proximity to a spring-fed mountain stream. The settlement, originally included in Spain's 90,000-acre Cañon de Carnué land grant, was almost entirely excluded when the grant was resurveyed by the U.S. government in 1901. Its residents—and many other area residents whose lands suddenly did not belong to them—were left fumbling to file their families' properties as homesteads. Back then—and as late as 1914, when the wedding invitation below was printed—the town went by El Cañoncito de Nuanes, a name that was shortened once the Nuanes family moved south to Tijeras. (Courtesy CSR, above; Dennis Lucero, below.)

NUPCIAS

Usted y familia son respetuosamente invitados á asistir al enlace conyugal de nuestros hijos,

Onesima Garcia y Oliveros Jaramillo,

el cual tendrá lugar el Lúnes 9 de Noviembre de 1914, en la capilla del Cañoncito de Nuanes, á las 8 de la mañana. Despues de la ceremonia se tendrá una recepcion en la residencia de los primeros, en la Punta de la Mesa, y en la noche á un lucido baile en la misma casa, en honor del enlace.

VIVIAN GARCIA y MARES y Esposa,
PLACIDA P. de JARAMILLO, Madre.
SEFERINO JARAMILLO y Esposa, Hermanos.

Most of the residents of early Cañoncito were poor and lived off whatever crops and animals they raised for themselves, whatever firewood they could chop and sell, and the occasional deer or turkey. As a result, the children in Cañoncito learned to work hard, working alongside their fathers in narrow corn and bean fields, or alongside their mothers around their homes. For a grade-school education, the children could attend school in San Antonito a short ways north, riding there and back—as seen in these c. 1930s photographs—in a horse-drawn covered wagon owned by a man named Francisco "Franké" Lucero, a trip made even during the legendary winters of the first half of the 1900s. The image below shows Cañoncito's San Lorenzo Church as well. (Both courtesy Maria Herrera Dresser and EMHS.)

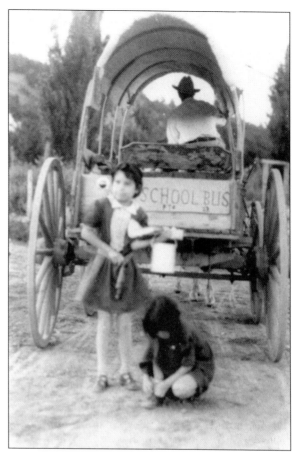

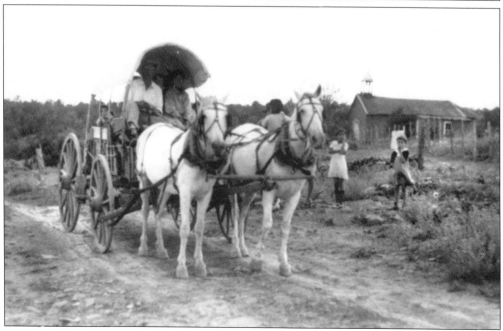

From its founding until the 1950s, most of Cañoncito's residents obtained their water from *acequias*—irrigation ditches—and a holding pond into which water from the nearby Cole Springs was rerouted. In the above photograph, area residents Elsie Trujillo, Virginia Trujillo, Teresita Salazar, and Lucy Lucero relax near Cañoncito's since-abandoned acequia, *c.* 1935, beneath a sign warning that "Any person who cuts breaks stops or interfers [*sic*] with this ditch shall be prosecuted." Behind them stands Cañoncito's San Lorenzo Church, a church built by the community sometime around 1870. Every August, locals still celebrate their annual fiesta there (much like the one glimpsed in the 1960s photograph below), dance the traditional Matachines dance, and honor St. Lawrence—the church's namesake, the patron saint of Cañoncito, cooks, sick people, and people with lower back pain. (Both courtesy Dean and Pat Campbell.)

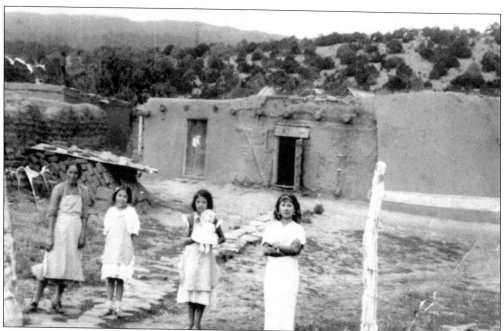

Homes in Cañoncito—like the one in the above 1940s photograph of Rita Salazar, Teresita Salazar, Margret Salazar, and Leonore Garcia—were almost always adobe and were typically equipped with dome-shaped outdoor ovens known as *hornos*. Some years, during especially severe winters, some residents would move into Albuquerque for the season, leaving their homes in Cañoncito unlocked so that people caught in snowstorms could have someplace to warm up. Cañoncito was like that. As shown in the photograph below of Benceslado Salazar, Andrese Salazar, and Melisandro Rael around the 1930s, the villagers would often help one another out and work together on various outdoor projects. "These occasions were always not only work occasions but they were very social occasions too," remembered former Cañoncito resident Bob Cooper in a 1991 interview. "Nearly everybody got drunk." (Both courtesy Dean and Pat Campbell.)

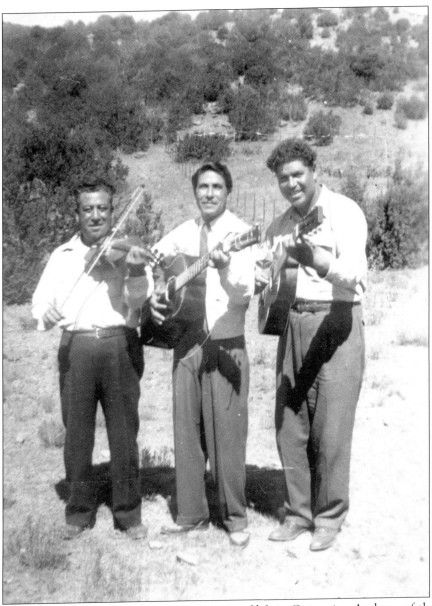

Annual fiestas have always been an important part of life in Cañoncito. And one of the most important parts of these fiestas has always been the music, played in small groups as entertainment, as part of the religious services, and as accompaniment for the traditional masked dancing of the Matachines. In this photograph, area musicians Jesus Trujillo, Lorenzo Zamora, and Jacobo Armenta play live at the Cañoncito fiesta on August 10, 1948. The songs played at these fiestas have been sung and played in these mountains for over a century, are almost always in Spanish, and occasionally reference area settlements and folk heroes. Jacobo Armenta, the guitarist on this photograph's right, was a well-known resident of nearby Tijeras—where he once worked at the now vanished La Luna Bar—and always made a point of playing for Cañoncito's fiestas. Jacobo started playing guitar as a teenager, became known throughout the mountains for his musical abilities and friendly demeanor, and left behind children who still play the same time-honored songs at the fiestas today. (Courtesy Dennis Lucero.)

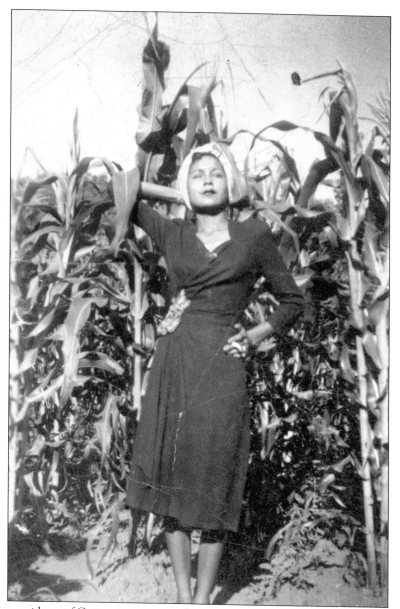

The old-time residents of Cañoncito were poor but resourceful. They planted gardens and crops and orchards, cured and dried fruits and vegetables to last the winter, raised chickens, made whitewash from crushed gypsum, and sold firewood. As late as the 1940s, men would take gunnysacks and hike high into the mountains to gather snow and ice from shaded crevices to cool down homemade beer; sometimes they would go on horseback and shoot themselves a deer on the way down. As generations passed, however, Cañoncito's land was divided and divided again between children and grandchildren, until farming plots became too narrow to be economically feasible and the fields of beans and corn were gradually sold and built upon. "Oh, we used to raise some corn up there, you wouldn't believe it," remembers former Cañoncito resident Dennis Lucero. "Seven, eight feet tall!" In this c. 1949 photograph, Dennis's sister, Rosella "Rose" Lucero, poses in a Cañoncito cornfield. In the 1960s, Rose owned Rose's Cafe down in Tijeras, serving "The Hottest and Best Spanish-Mexican Food in Tijeras Canyon." (Courtesy Dennis Lucero.)

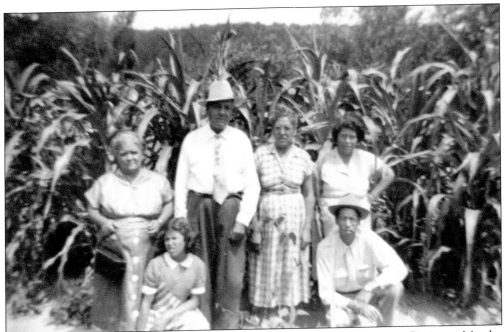

Many people have lived in Cañoncito. In the image above, residents Eurcenia Gutierrez, Martha Lucero, Antonio Gutierrez, Rufina Lucero, Qiteria Gutierrez, and Rufina's husband, Manuel Lucero, gather in a Cañoncito cornfield in March of 1958. Many people have died in Cañoncito as well. In the postcard below, c. the 1920s, the body of Cañoncito resident Manuel Salazar rests in a Cañoncito home. During his lifetime, Salazar married a girl from San Antonio and fathered three children. During its lifetime, Cañoncito has been taken from its residents when the government changed, sold away when its people could not pay their property taxes, seen a tornado tear across it in the early 1950s, and had its farms replaced with middle-class homes. It's changed, but it hasn't died. It hasn't died, but it's changed. (Courtesy Dennis Lucero, above; Dean and Pat Campbell, below.)

Seven

SAN ANTONITO

Travel north once again along State Highway 14, among ridges and hills and side roads. Head up and over a long, slanting incline known historically as El Bordo—"the ridge"—and coast down Hansen's Hill, a forest-lined descent named after the owners of a now defunct hillside restaurant. Watch how an undulating ridge of the Sandias' peaks swings along the western horizon, and notice how the highway seems to steadily curl and fall away from it. Watch the sky widen. Watch the view to the north and east level out into choppy foothills and the plains beyond. And watch the distant desert swells of the San Pedro and Ortiz Mountains as they join the Sandias in rising over a village.

The village of San Antonito can sometimes seem like nothing more than a part of nearby Sandia Park, like the intersection of Frost Road and the highway, or like merely a place with a gas station and a good Mexican restaurant. Like all the towns of the Sandia Mountains, however, San Antonito has a story.

According to well-known area old-timer Jose Rael, in the early 1840s the nearby community of San Antonio had a feud that resulted in certain families leaving San Antonio, moving about five miles north, and founding a village of their own, the village of San Antonito. This story may be little more than legend, but the two towns' names do suggest a connection: San Antonio means, "St. Anthony," and San Antonito means, "little St. Anthony." Also, around 1844, right around the time of Rael's story, the land for San Antonito was granted to area residents by the Mexican government.

However it came into being, San Antonito soon grew into an active little town of woodcutters and farmers, with its own store, church, cemetery, and schoolhouse, and the town is still growing today.

"When we come home in the evenings, and we turned off [State Highway] 10 onto Frost [Road], there were no lights on," recalls area resident Marion Rider about the town in the 1940s. "No lights. Now it's all sparkly and electrified."

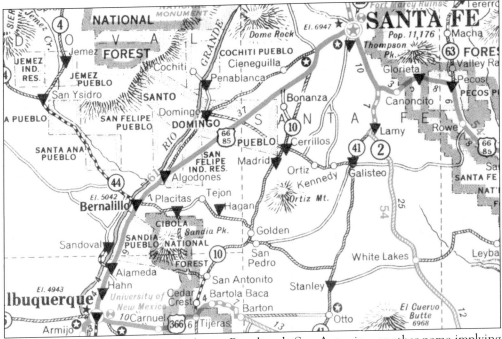

Occasionally referred to in its early days as Ranchos de San Antonio—another name implying it began as an outgrowth of San Antonio to the south—San Antonito became an important trading point at the intersection of today's State Highway 14, State Road 536, and Frost Road, the latter missing from this 1930s roadmap. (Courtesy Pam McCoy and Paul Black.)

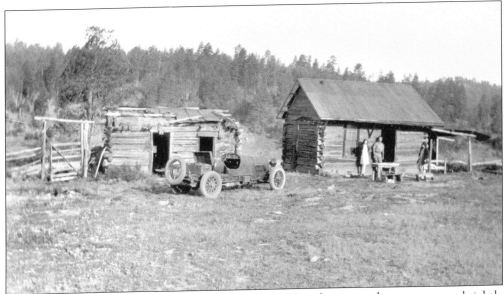

On the southeast corner of State Highway 14 and Frost Road now stands an enormous, brightly lit gas station. But from 1960 to 1998, that corner was the site of the locally infamous Windmill Bar and Restaurant. And before that, it was home to a 1920s cabin, used perhaps as a getaway for an Albuquerque family, and perhaps the setting of this 1920s photograph. (Courtesy Jamie Morewood Anderson.)

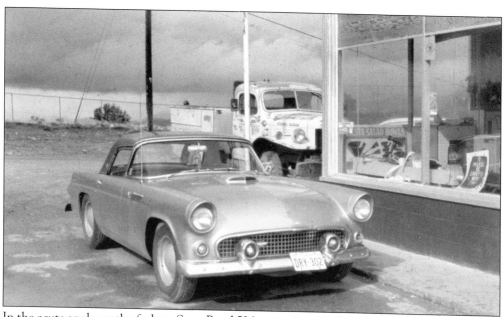

In the acute angle south of where State Road 536 meets State Highway 14 is a large, grassy, three-cornered median known as The Triangle, a name also applied to the entire intersection. On that median, in the 1960s, once sat the Sandia Texaco, seen in this 1970 photograph—a gas station with a repair shop, a store, and a parking spot for the local fire truck. (Courtesy Ron Overall.)

This image shows Mary Davis, Leonard Skinner, and Cecilia Montes Skinner sometime around 1880. Leonard Skinner was a New York Protestant known as "The San Antonito Lumber King"; his wife, Cecilia, was from New Mexico, and Catholic; and Mary Davis was their orphaned niece. Despite not being Catholic, but because he loved his wife, Leonard donated all the lumber needed for the local church's roof and floors. (Courtesy Cecilia Cardwell and EMHS.)

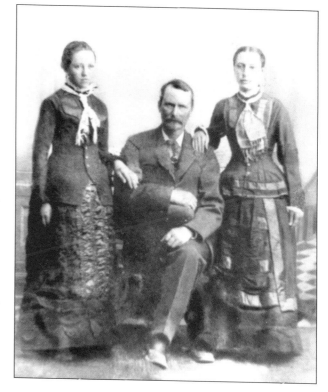

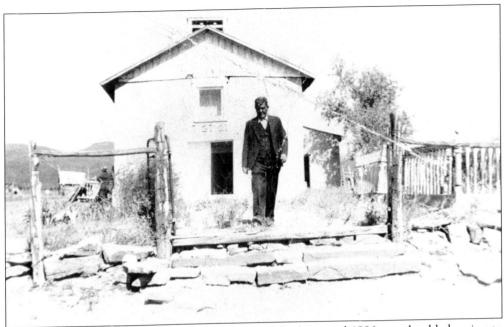

San Antonito's well-preserved Catholic church was built around 1886—on land belonging to farmer Julian Romero and his wife, Serefina Zamora de Romero, and with adobe bricks either made by locals or taken from a much older church located a ways north. Selso Garcia, seen here around the 1930s, was a farmer, church caretaker, and occasional coffin maker, and is now buried in the church's cemetery. (Courtesy Melba Scott.)

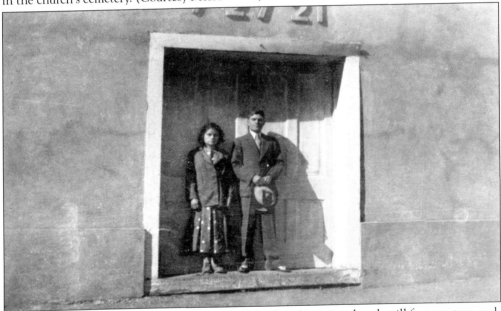

Originally constructed without its sloping roof, the San Antonito church still features two-and-a-half-foot-wide adobe walls, an attic insulated with dirt, and a bell tower hammered together with wooden pegs. In 1921, the church was plastered, and the date "7-27-21" mounted above its front door. In the church's doorway in this 1930s photograph are Corina and Hipolito Garcia, the children of well-known locals Selso and Lucardita Garcia. (Courtesy Melba Scott.)

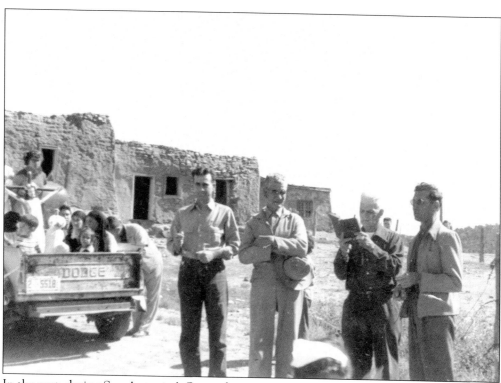

In the past, during San Antonito's September fiestas, locals would close both ends of the highway, line the road with food-covered tables, and carry Señor de Mapimí—the church's sacred image of Christ—on a procession through the community, as they're doing in this post-1941 photograph. The man reading is Juan Garcia, and the man to the right of him is Francisco Lucero. (Courtesy Dean and Pat Campbell.)

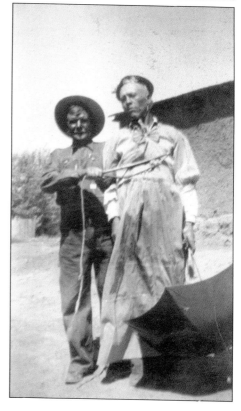

The traditional dance of the Matachines plays a prominent role in the fiestas of San Antonito, with each of its main characters—the *Abuelo*, *Danzante*, *Malinche*, *Monarca*, *Perejundia*, and *Toro*—possessing his or her own symbolism and historical counterpart. In this 1930s photograph, Ramon Garcia plays the Abuelo, representing the people's spirit, and Vincente Gurule plays the Perejundia, representing temptation. (Courtesy Dorela Perea and EMHS.)

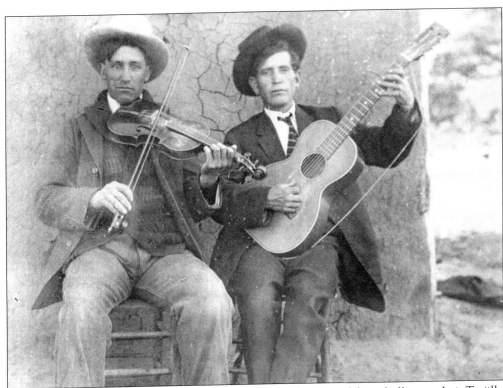

This photograph, taken perhaps during the 1920s, shows farmer and dancehall owner Luis Trujillo on violin, and Hispanicized American Indian Isederio Candelaria on guitar, playing music outside of an adobe dancehall that once stood immediately north of the San Antonito church. Los Musicos (musicians) have always been an essential accompaniment for every Matachines dance, as well as for festive occasions in general. (Courtesy Dean and Pat Campbell.)

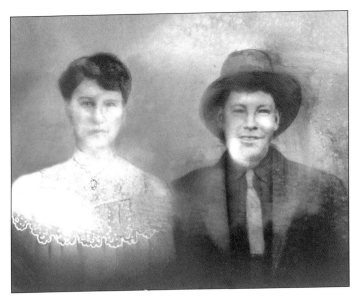

Wife and husband Inez Olguin Gutierrez and Antonio Gutierrez—shown in this 1903 photograph—lived and farmed on the eastern outskirts of San Antonito, in the community of Frost, or Frosté. Antonio was a member of the secretive Penitentes religious sect; Inez bore five children. Antonio and Inez gave their two-year-old daughter, Raquel, to Inez's father, Maximo Olguin, to raise, and Raquel quickly died of loneliness. (Courtesy Dennis Lucero.)

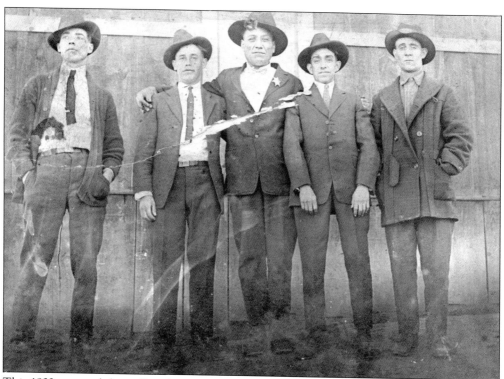

This 1922 postcard shows San Antonito resident Fidel Baca in the center of four unidentified others. Fidel Baca was born around 1888, and worked as a farmer, most likely growing corn and pinto beans, peas, squash, and chile—all common crops around San Antonito. Perhaps because of his abilities to read, write, and speak English, however, he was also chosen to serve as an area lawman. (Courtesy Dennis Lucero.)

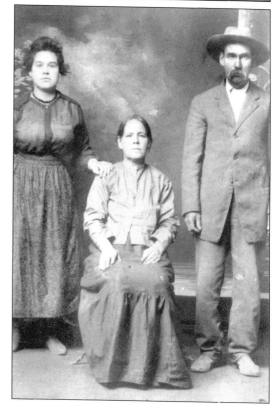

Near San Antonito's main intersection, The Triangle, once lived the Garcia family, Colastica and Valentino Garcia, who are pictured in this early 1900s postcard to the right of their daughter, Angelica Garcia. Valentino was a laborer and farmer, sometimes danced the Matachines dance, and was one of many San Antonito residents who helped to build the San Antonito church. (Courtesy Dean and Pat Campbell.)

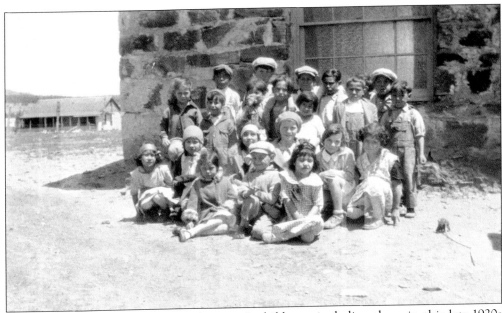

From the 1920s to the 1950s, San Antonito's children—including those in this late-1920s photograph—attended a single-room stone schoolhouse, not far northeast of the church. The school's Anglo teachers required all Spanish-speaking children to take the first grade twice: once to learn English, and once for the curriculum. "Spanish kids learned English great," remembers former student Justin Grabiel. "But white kids just learned Spanish swearwords." (Courtesy June Berry.)

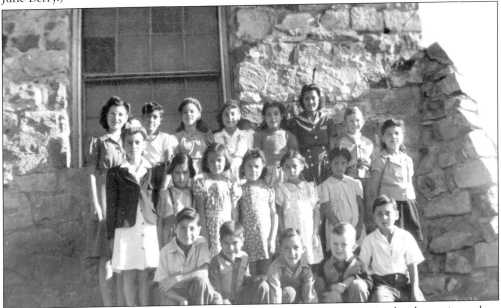

In the San Antonito school's early days, it is said that Bernalillo County's school superintendent signed his name "X," and that occasionally children would rope off the school's porch as a makeshift wrestling ring. This early 1950s photograph shows students against the school's buttressed back wall, with their teacher, Albenita Rael. That school is now abandoned, and San Antonito's children meet in a much larger building up the road. (Courtesy Justin Grabiel.)

Several decades ago, although San Antonito had fewer businesses and buildings, its cornfields and bean fields covered miles, stretching in all directions. Remembers lifelong resident Dorela Perea, "Everybody wanted to come here because of all the open space." This 1960s photograph shows the area north of the main intersection, facing north toward the Ortiz and San Pedro Mountains. (Courtesy Dorela and Roberto Perea.)

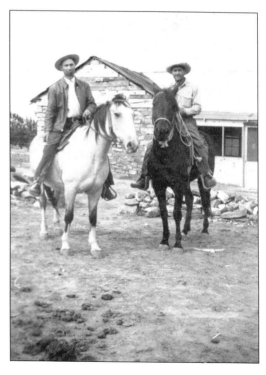

With very few exceptions, residents of the towns of the Sandia Mountains have generally coexisted peacefully—moving between towns, choosing spouses from them, and attending neighboring towns' fiestas. This 1942 image shows Jose Perea and Roman Lucero—Jose from around Frost, and Roman from San Antonito—riding horses together around San Antonito's eastern outskirts. (Courtesy Dorela and Roberto Perea.)

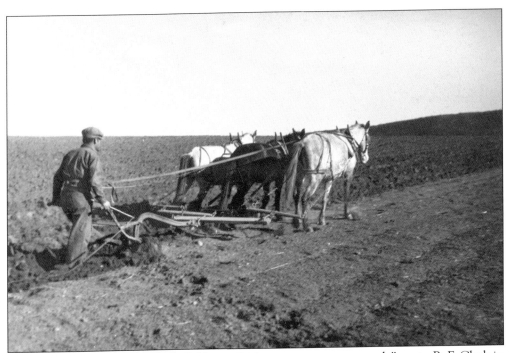

"All around the village were little fields in which some men were at work," wrote B. F. Clark in his locally set 1946 novella *Fiddlers 'N' Fishermen*, seemingly describing these *c.* 1937 and 1945 photographs. "In one field a man was plowing. In another a man was harrowing. The two fields adjoined each other, with a fence between them. The two men, having made a round in their fields, came back to the fence between them at the same time. Turning their teams around, and taking their lines from their shoulders, and dropping them to the ground, left their teams standing still. Then each man sat down on the ground and leaned back against a fence post, lit a cigarette, sat there and smoked it while they had a little visit." (Courtesy CSR, #000-289-0361, above; Marion Rider, below.)

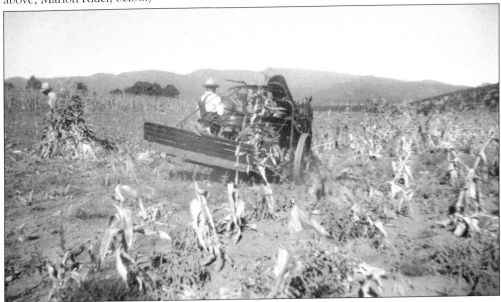

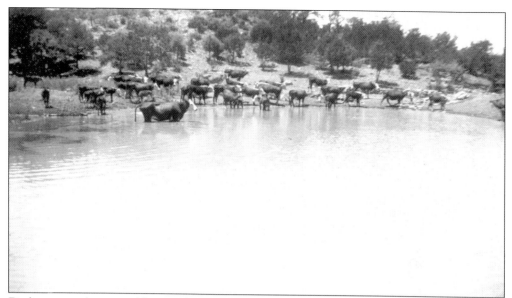

Finding it nearly impossible to make a living farming, local man Harold Rider began working on Thomas D. Campbell's cattle ranch—maintaining, branding, feeding, and herding. Whenever it was time to round up all the cattle, Harold would close the gates to the cattle ponds—like the pond in this July 9, 1944, photograph—so the cows couldn't swim out to where he couldn't reach them. (Courtesy Marion Rider.)

What was once the wide open Campbell Ranch, around San Antonito's northern end, has become multiple planned communities with roads, houses, and a golf course. Across from those developments, however—on the eastern side of the highway and not far southwest of the ruins of the Tiwa India pueblo known as Pa'ako—there remains a cluster of the ranch's old corrals, shown here in this June 1960 photograph. (Courtesy Marion Rider.)

The 1944 photograph above shows three friends and local June Shahan cooling their feet in San Antonito's spring-fed acequia. The October 1944 photograph below shows June Shahan and a girlfriend in front of the Shahans' screened-in porch, from which June remembers hearing the acequia burbling past as she would fall asleep. "It was a ghost town out there," she says of that time, and it is true that from the start of World War II until well into the 1950s, residents left town in large numbers to work defense-related jobs elsewhere. Hispanic old-timers moved out, and middle-class Anglos moved in. Today the roads are wider, the fields have been built on, and the acequia is dry, but the town is not a ghost town. It is a place with a past, an identity, and a history that has not stopped. (Both courtesy June Berry.)

Eight

SANDIA PARK

And now, head up.

From the open horizon of San Antonito's main intersection, turn west onto the two-lane State Road 536—into the mountains, up the mountains, into a crowding forest of pine and juniper, and past a small green sign announcing Sandia Park: a place whose only center is the road out of it. Sandia Park is a mountain community far more mountain than community, where the number of ponderosa pines increases with the number of feet above sea level, red-brown rocks protrude from wooded hillsides, old and angular cabins hide behind trees, and Cienega Creek trickles into a shining manmade pond.

Settled around the 1920s along the road to the Sandias' highest peak, Sandia Park began as a loose collection of high-altitude summer homes owned by affluent families from Albuquerque. In November 1925, a man named Hezekiak "H. B." Hammond became Sandia Park's first postmaster and very likely gave the community its name. Hammond was an area forest ranger, a homebuilder, and developer. He would buy land, subdivide it, build cabins on it, and then sell it, and is sometimes regarded as the community's founder. Another factor in Sandia Park's settlement, however, was the 1928 filing of the Sandia Park Country Club Addition—an informal development connected to an Albuquerque venture that rewarded people who bought land in the city, by selling them discounted lots in the mountains. From 1933 to 1941, members of the Civilian Conservation Corps camped in Sandia Park, made improvements to State Road 536, and left the settlement much more accessible than it had been. By 1936, Sandia Park had its own community store, and by 1938, 36 families lived in the community year-round, and even more owned summer homes or rented cottages there.

Today the area historically known as Sandia Park—between San Antonito and Cibola National Forest—contains barely seven percent of the homes with a Sandia Park mailing address. Sandia Park's name has spread in almost every direction, over foothills and plains and other communities, but its heart remains in the mountains.

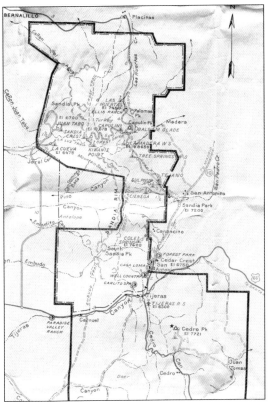

Cibola National Forest has districts scattered across New Mexico, Texas, and Oklahoma, and this 1936 map shows its Sandia Mountains region. It also shows Sandia Park at the intersection of State Highway 14 and State Road 536, although that crossroads would more accurately be labeled as the town of San Antonito; Sandia Park's dot should appear just west of that on State Road 536. (Courtesy Rick Holben.)

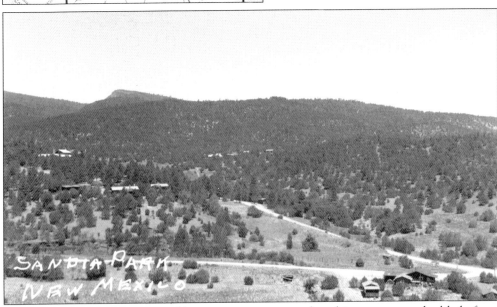

Showing a scene not incomparable to its appearance today, this rare postcard—likely from around the 1940s—shows a panoramic view of early Sandia Park. The road in the foreground is known today as Cienega Canyon Road, the building in the bottom right corner was the local store, Tilton's, and the road sloping over it was the old road up—State Road 536, or the Crest Road. (Courtesy Justin Grabiel.)

Sandia Park could be considered an outgrowth of San Antonito, but it could also be considered a suburb of Cibola National Forest, as it contains far more trees than people. Sandia Park's close proximity to the pine-filled valleys and forested mountains of the National Forest has kept the road through the community's center zipping with summer tourists, but it's also stopped Sandia Park from spreading westward, and preserved the community's sylvan character. In the above photograph, dating from around the 1940s, members of the U.S. Forest Service—an agency of the U.S. Department of Agriculture—load up a truck with area locals for a daytrip through Sandia Park and into the mountains. And in the 1930s photograph below, ranger Gavino Campbell pauses while at work in one of the Sandias' higher areas. (Both courtesy Dean and Pat Campbell.)

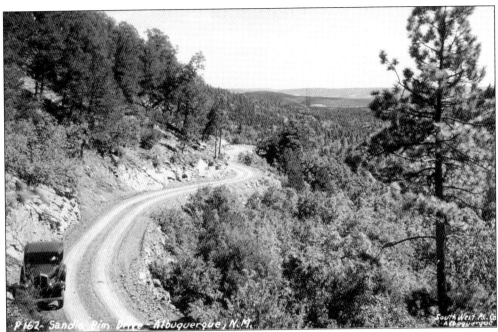

Sandia Park owed its popularity in large part to the people who drove through it en route to Sandia Crest to see the view from the mountains' highest peak. Albuquerque residents would drive up the mountain along the then dirt road, see quaint little cabins for rent in a gorgeous setting, and later come back to stay a little longer. This postcard dates perhaps to the 1940s. (Courtesy Nancy Tucker.)

The road up to 10,678-foot-tall Sandia Crest, right through Sandia Park, was advertised on billboards and bumper stickers—like the 1940s sticker shown here—as a driving adventure. And, with State Road 536 –a.k.a. Sandia Crest National Scenic Byway, a.k.a. Rim Drive, a.k.a. Loop Road, a.k.a. the Crest Road—having sharper curves, a rough dirt grade, and being narrower than it is today, the trip must have been somewhat thrilling. In the early 1900s, local timber baron Leonard Skinner

State Road 536 began as a haphazard collection of timber roads, took shape between 1922 and 1927 as a single-lane track to Sandia Crest, and was reinvented in the 1930s by shovel-wielding members of the Civilian Conservation Corps. This post-1933 motoring guide to the Sandia Mountains illustrates the appeal the road has always had as a getaway for New Mexico's visitors and residents. (Courtesy Rick Holben.)

spent over $1 million of his own money to build a road up to the mountains' highest peak, with big plans of logging trees there. Shortly after its completion, however, the Forest Service declared logging in the area off-limits, and Leonard lost his entire investment. Later road-builders almost certainly benefited from the costs of his endeavor. (Courtesy Rick Holben.)

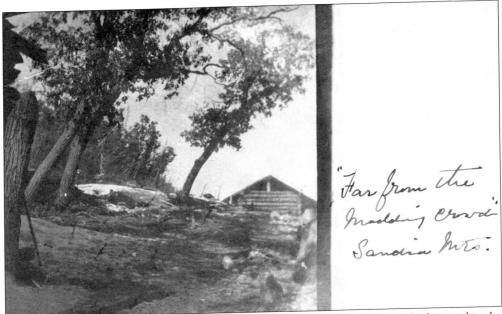

Although Sandia Park did not have an official name until 1925, random cabins had existed in the area for decades, like the one on this unique 1910 postcard mailed from the village of Placitas, at the mountains' northern end. "Far From the Madding Crowd" is an allusion to Thomas Hardy's 1874 novel of the same name, and is a description that still fits Sandia Park today. (Courtesy Nancy Tucker.)

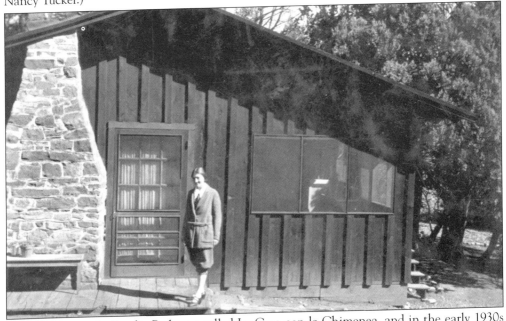

One cabin in early Sandia Park was called La Casa con la Chimenea, and in the early 1930s it became the seasonal rental home of National Book Award–winning author Conrad Richter and his family. Richter rented the cabin hoping the mountain air might soothe his tubercular wife Harvena "Harvey" Richter—shown at the cabin in this 1930s photograph—and to help his Depression-affected family save money on rent. (Courtesy Harvena Richter.)

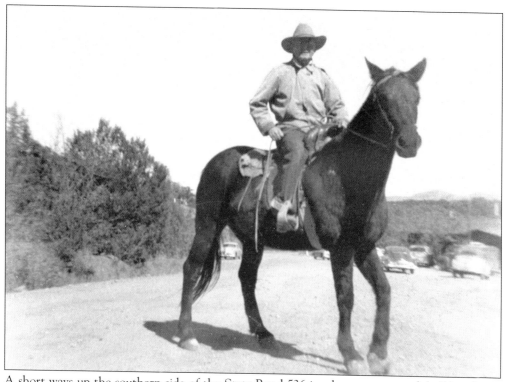

A short ways up the southern side of the State Road 536 is a large green pond, bulldozed into shape by Monroe "Monte" Rossiter, a local man who also claimed to have invented the Ouija board. And just west of the pond—until its closure in 1970—was once Tilton's Store, shown in the above early 1950s photograph behind area man Paul Grabiel. The store was an important area supply point, as well as the home of Sandia Park's post office. It was opened around 1936 by a tubercular man named Vance Tilton, run with his mother Cora Tilton's help when Vance's health worsened, and passed on to Vance's younger brother—Corwin "Bill" Tilton—after Vance finally died in 1946. The photograph below shows store employee Dean Campbell working inside in the early 1960s. (Courtesy Justin Grabiel, above; Dean and Pat Campbell, below.)

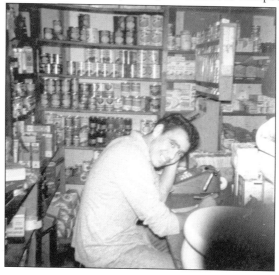

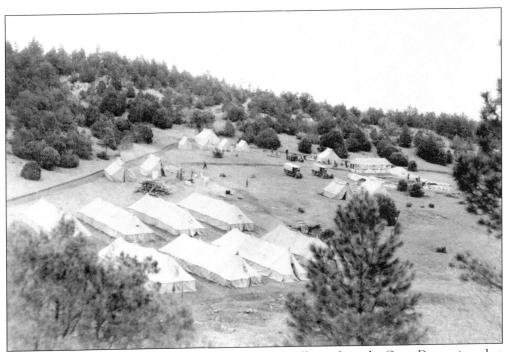

It is strange to think that, just as most of America was suffering from the Great Depression, that very same depression was resulting in perhaps the most vibrant, hopeful, and bustling scene in Sandia Park's history. In 1933, as part of an even larger national relief effort, Pres. Franklin Roosevelt established the Civilian Conservation Corps, or the CCC, a program to hire the country's unemployed young men to make improvements on public lands. Sandia Park became the location of one of the first New Mexican CCC camps. That camp, Camp F-8-N, was located from 1933 to 1935 in nearby Sulphur Canyon—shown above c. 1933—but was subsequently moved to the area in the 1930s image below, just north of today's unique Tinkertown folk art museum, and lasted there intermittently until 1941. (Courtesy AM, #1980-063-946, above; Dirk Van Hart, below.)

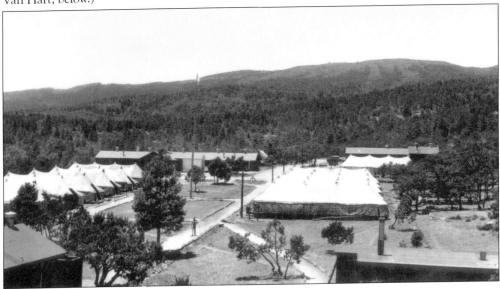

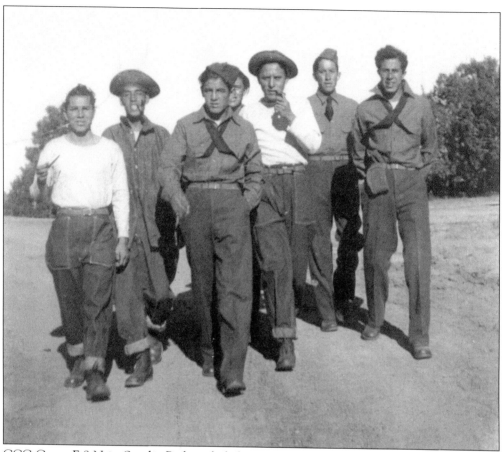

CCC Camp F-8-N in Sandia Park included young men from Tijeras, Sandia Park, Placitas, Albuquerque, and all over New Mexico. The camp's collective membership, Company 814, was overseen by reserve officers from the U.S. Army, and its members were expected to work 40 or more hours a week on tasks such as improving roads, building campgrounds, or planting trees, and were required to send up to 25 of their monthly $30 salaries home to help their families. On weekends, CCC "huskies"—like those in the above 1930s photograph—would go down to San Antonito to dance, drink beer, and mix with local girls. Generally, however, the boys were disciplined and hard-working, and many of the area campgrounds and roads they built are still in use today. The photograph below shows members of Company 814 in 1936. (Both courtesy Dirk Van Hart.)

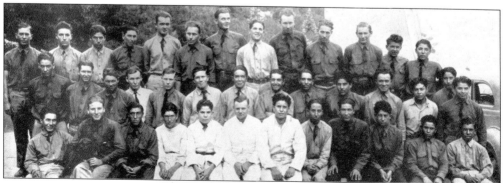

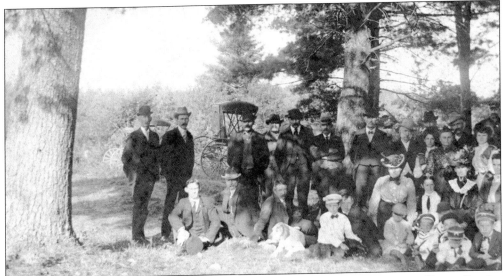

In 1903, the road up the mountains could have been little more than—as one Forest Service booklet put it—"a series of wood cutting routes and logging skid trails," and yet for the reunion in this photograph, these people made it up it in horse-drawn buggies—four years before there was a Cibola National Forest, and 22 years before there was a Sandia Park. (Courtesy Jamie Morewood Anderson.)

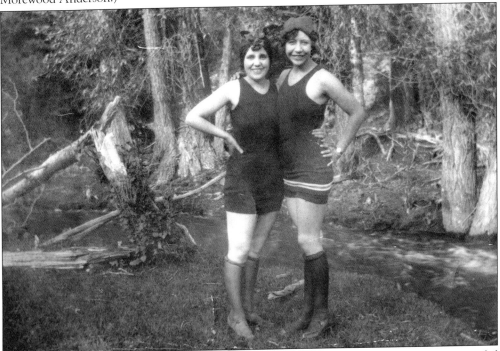

Just west of Sandia Park is the Doc Long Picnic Ground, Bill Spring, and a lovely spring-fed creek. The picnic ground and spring were named for Dr. William Long, who studied tree diseases there, and it was probably by the creek that this photograph was taken around the 1920s. One of the women shown is Albuquerque resident Petrita Rodriguez, winner of a 1932 statewide beauty contest. (Courtesy Rick Holben.)

Just west of the Doc Long Picnic Ground is Tejano ("Texan") Canyon, where in the 1870s, Leonard Skinner, "The San Antonito Lumber King," opened a large and prosperous sawmill. Later, in the 1920s, Tejano Canyon became a popular hideaway for fraternity and sorority "necking parties" from Albuquerque's University of New Mexico. One such Tejano Canyon party is featured in these late-1920s photographs—the above of a male student with Gertrude Magee, and the below of "Ella B. and Ullrick," holding the cushioned back seat of the car they rode up in. Gertrude Magee was the daughter of Carl Magee—the founder of the *Albuquerque Tribune*—and she would later marry a physicist gardener named Tony Grenko and with him run and improve the Carlito Springs resort in Tijeras Canyon, at the Sandias' southern end. (Both courtesy Chip Bergland.)

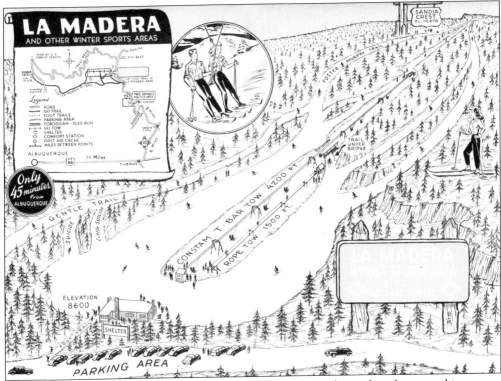

Few communities in the mostly desert state of New Mexico are located as close to a ski resort as Sandia Park, which sits just a few miles east of one. Founded in 1936 by early skiing enthusiast Bob Nordhaus, Sandia Park's neighboring slopes were then known as the La Madera Ski Area, after the Sandia Mountains' La Madera Canyon. As shown on the 1950s tourist map above, the ski area soon had two crude tow systems, numerous trails, and a log cabin lodge built by the Civilian Conservation Corps in 1938, that's also featured in the 1940s postcard below. In 1962, the resort changed its name to Sandia Peak Ski Area, but it has continued to offer Sandia Park residents yet another reason to be happy about where they live. (Courtesy Rick Holben, above; Nancy Tucker, below.)

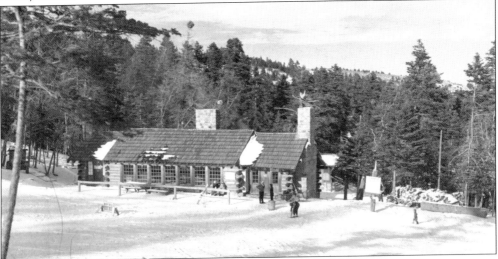

Nine

PLACITAS

To drive west from Sandia Park is to drive *up*. The road turns, and buildings vanish, and nothing remains but mountains and valleys, the green softness of trees, and the terraced crags of tilting cliffs. Pines fall past, rocks rise up, oaks fall past, and the picnic ground of Balsam Glade appears on the right. Here, slip down onto the southern dirt end of State Highway 165, a road enclosed by trees and their shadows, a road that bursts out occasionally along bottomless valleys and that winds past a historic homestead, the sad site of an unsolved murder, and the dark cliff-set keyhole of Sandia Cave—where archeologists discovered tools perhaps 12,000 years old in the 1930s. The road crosses from Bernalillo into Sandoval County, follows the spine of the Sandias north for about nine miles, drops down the mountains' northern end, gains pavement, and opens out among green-brown desert foothills and the scattered homes of the village of Placitas.

Possessing a rich American Indian past, and the site of more than one early Spanish mining effort, Placitas ultimately began around 1765 when San José de las Huertas—"St. Joseph of the Gardens"—was settled as a walled outpost to defend Albuquerque from the mountains' native tribes. Around 1823, the settlement was evacuated due to increasing raids, but around 1840 its residents returned to found Placitas—a tiny farming community crisscrossed with lush acequias. Since then, Placitas has seen a rush of Anglo miners in the mid-1800s, divisive turn-of-the-century contention between Catholics and Presbyterians, and the founding of numerous hippie communes in the 1960s and 1970s when, as resident Lynn Montgomery says, "We were the whole region's homeless shelter."

Today's Placitas is anything but that: Interstate 25 now runs nearby and has brought thousands who have discovered they can work in Albuquerque but live in Placitas, and new, often multi-million-dollar homes go up constantly. But the town's diverse history remains. Take a random Placitas side road to its end, and almost anything might present itself: hippie-built geodesic domes, ancient rock and adobe walls, or an open patch of desert . . . with nothing else around for miles.

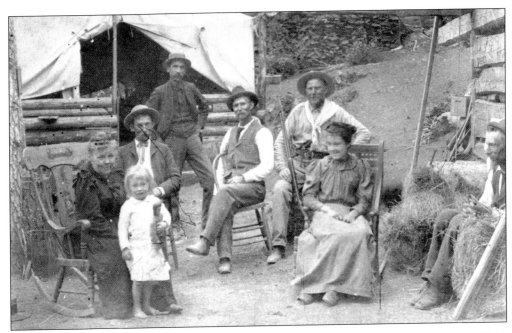

Located about six miles south of Placitas along State Highway 165, Ellis Ranch is a spring-speckled, densely forested mountain homestead. The ranch was first settled around 1889, by a tubercular Union Civil War veteran named George Ellis, his tubercular wife, Julia Ellis, their six children, and George's widowed mother, Eliza Carter Ellis. For some time, the Ellises lived in the tent shown above *c.* 1893, while George and his sons built the two-story cabin shown below *c.* 1896. Later that cabin was made part of the only homestead in the high Sandias, sold to Dr. Hugh A. Cooper—founder of Albuquerque's Presbyterian Hospital, and one-time owner of the Sandias' Well Country Camp sanatorium—resented by activists angry about a homestead being in a national forest, and ultimately destroyed by an arsonist in 1991. (Both courtesy Bob and Kay Cooper.)

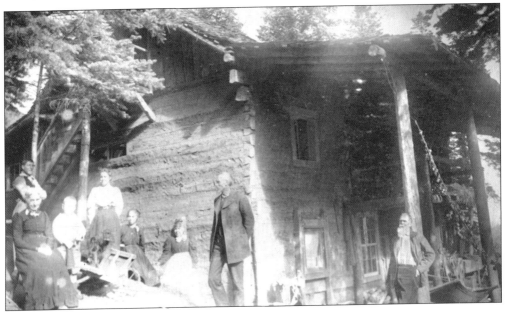

When they first settled Ellis Ranch, George and Julia Ellis had six children. Guy was 21 and helped his father build their house. Maud, 19, was skilled at domestic work. Charlotte—pictured above skiing *c.* 1896—was 17. Charlotte earned money selling plant specimens to international botanical gardens, helped teach her youngest siblings to read, and named every animal on the ranch. (One steer's name was Hans Higgins.) Augie, who later made Charlotte's skis, was 12 and later shot the Sandias' last recorded grizzly bear. Frank was only nine, and sickly, and eventually left home young and lost all contact with his family. And the youngest Ellis, Paul, was born in Albuquerque just before moving up to the mountains. In the 1893 photograph below, Paul stands in his nightclothes beside nearby Las Huertas Creek. (Both courtesy Bob and Kay Cooper.)

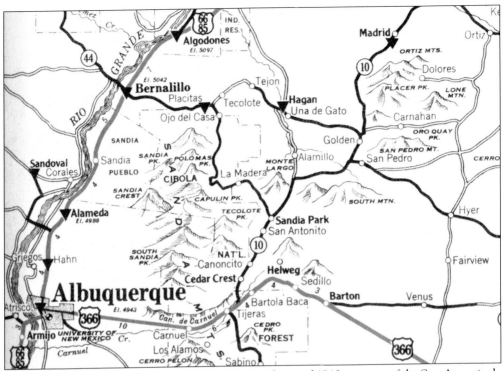

When the Spanish resettled the Sandias' northern end around 1840—as part of the San Antonio de las Huertas land grant—they chose the unoriginal but fitting name of *Placitas*, or *Las Placitas*—"the towns"—to refer to the area's collective settlements. These settlements coexisted with the now faded Ojo de la Casa and Tecolote, both shown on this somewhat inaccurate 1930s roadmap. (Courtesy Pam McCoy and Paul Black.)

In a way, the partially dirt, partially paved road through Placitas is the village's ideal metaphor—half rough and earthy, yet half slick and new, coming then going, and steadily changing. Just west of Placitas, that road once met with U.S. Highway 85, the highway shown on this perhaps 1950s postcard. This thoroughfare would later become a frontage road for Interstate 25. (Courtesy Nancy Tucker.)

110

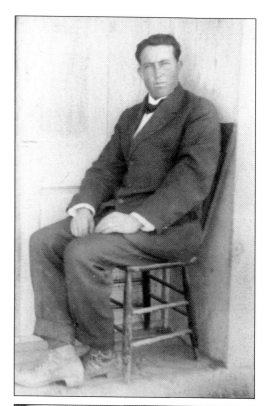

Residents of the Placitas area have seen a lot of change, and it has not all been easy. Its indigenous people must have watched with some anxiety when the first bands of armed Spanish men rode through, and its earliest Spanish residents must have worried when the state's oppressed natives rose up to temporarily drive them out of New Mexico in 1680. And of course, not everyone in Placitas liked hippies camping in their backyards throughout the 1970s, just as many of the hippies who stayed around don't like the extensive new developments being built there today. Two of Placitas's bygone residents were David and Teresita Trujillo, pictured here on February 9, 1915. David liked to roam and could never stay in one place very long. Teresita, his wife, was a schoolteacher. (Both courtesy Ora and Dora Corea.)

David Trujillo, pictured on the previous page, was the son of ranchers Julianita and David Tafoya Trujillo, shown in this hand-tinted, c. 1920s portrait. Julianita and David were born in the 1870s. After they married, they cleared a piece of hilly Placitas terrain and built a house. Their descendants still live in that house today and swear the old building is haunted. (Courtesy Ora and Dora Corea.)

Sometime in the 1940s, army general Kenner Hertford moved his family just east of today's Tunnel Springs Road to a Placitas ranch that had previously been the site of ancient Indian fields, early 1900s mines, and a nudist camp with a tree house. General Hertford was a key player in the Atomic Energy Commission, built a bomb shelter on his property, and searched the Sandias for uranium. (Courtesy Chuck Scott.)

Mining has played a stronger role in Placitas's history than it has in perhaps any other Sandia town's. Around 1667, the Spanish worked at least five mines around the Placitas area, using American Indian slave labor. One of these mines was the legendary Montezuma Mine, where stories say at least one man mysteriously disappeared while trying to remove the mountains' gold. In the 1800s and beyond, Anglo miners followed excited rumors into Placitas and the northern Sandias, grabbed land wherever they could—even if it was already owned—and dug up the mountainsides in search of copper, silver, and gold. The photographs on this page show an early-20th-century coalminining operation— perhaps around the 1920s— located on property now attached to the Hacienda de Placitas Bed and Breakfast. (Courtesy Jennifer Burkley, Max Vasher, and the Hacienda de Placitas.)

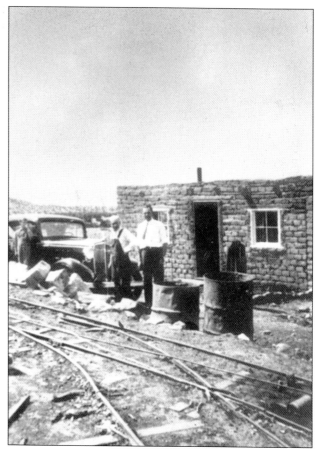

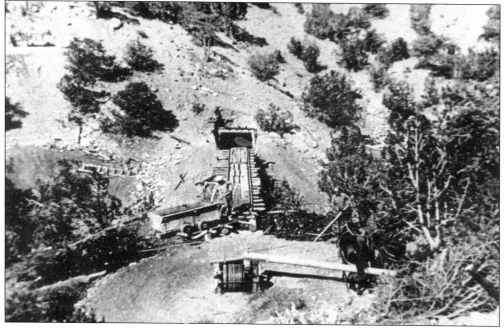

In the 1960s and 1970s, clued in by magazines and word-of-mouth, hundreds of restless, idealistic youth from around the world descended on the open foothills around Placitas and established the hippie settlements of Dome Valley, Lower Farm, Tawapa, and Sun Farm. The photograph above shows Sun Farm. Below is Tawapa. "The scene *kind of* started out purely motivated," recalls one former Placitas hippie who prefers to remain anonymous. "We professed great, altruistic motives, but in reality self-indulgence is what it was. It kind of deteriorated to the point where it was nothing but alcohol and drugs, just a place where people could go to get laid. The drugs gave you the illusion of inner completeness, limitless knowledge, and so on, but really there was a lot of darkness." (Courtesy Debra Lynn Stadelman; special thanks to Lynn Montgomery.)

Many good people did live in the Placitas communes—idealistic types who genuinely wanted to raise their own food, escape from mainstream society, and live communally—but, unfortunately, criminals and drug addicts lived there as well. One man starved his dogs and horses almost to death when he thought they were possessed by demons. One girl left her baby in the sun until its skin was red and peeling, and then used its burns to gain sympathy and solicit money. And the communes' unofficial spokesman, "Ulysses S. Grant"—featured here in a late-1960s self-portrait, and allegedly the reincarnation of the U.S. president with the same name—shot to death two commune members in a hazy 1970 incident involving drugs and Vietnam War flashbacks, before fleeing the state. "*That* is probably why it was doomed for failure," reckons an anonymous former hippie. "The drugs started taking their toll. And then cocaine hit. And that was it."

A 1909 issue of *South-Western Mines* revealed that Placitas-area miners had just struck high-grade silver ore and were digging a deep tunnel into the mountainside to intercept the vein. That tunnel, pictured above in the late 1940s, would soon intercept a spring, completely flood, and later provide water for, according to the 2005 *Field Guide to the Sandia Mountains*, "a fish hatchery . . . reported to have doubled as a party house and brothel." Later the mine would be dynamited shut and become the spring shown below with local Annie Hertford in 1949—Tunnel Spring—the namesake of today's Tunnel Springs Road. The initials "K.O.P.," once painted above the mine, stood for "Keep Out, Please"—and in many ways expressed the attitude of some Placitas residents about the rest of the world's growing interest in their town. (Both courtesy Chuck Scott.)

Ten

ALBUQUERQUE

Leave Placitas, and leave the mountains. Take State Highway 165 westward, downward, and watch the world ahead flatten out, the Sandias rise close and real to the south, faux adobe homes scatter across the roadsides, and tattered dirt mesas stretch along the desert to the north. Float along fast with the highway's motorized current, into the town of Bernalillo, and into the asphalt rapids of southbound Interstate 25. Course along beneath the mountains, through 15 desert miles of the Sandia Indian Reservation, and from Sandoval into Bernalillo County. Exit onto Tramway Boulevard, and follow that east and then south, along the eastern edge of the city of Albuquerque.

If *Towns of the Sandia Mountains* had been written just a few decades ago, it probably would not have included a chapter on Albuquerque—New Mexico's most populous city—because until recently, Albuquerque wasn't really in the Sandias. Founded in 1706 as a colonial Spanish villa, Albuquerque's rise to regional prominence was almost assured by its abundant resources and central location. In 1880, almost four decades after New Mexico had become American territory, the railroad came to town—as did people, and the town boomed. Tuberculosis patients seeking a healthful climate, travelers on the newly built Route 66, World War II veterans who discovered the city while stationed there, and Atomic Age scientists would all eventually settle in Albuquerque, swelling the city's limits up onto the mesa east of town, and then as far east as the mountains would allow.

Today eastern Albuquerque is the Wild West paved over—with grasses and sand and Circle Ks, mountains and sky and traffic lights. Tramway Boulevard beelines south, and the great gray wall of the Sandias runs parallel to it, with steep wooded valleys and high grooved inclines, a line of communications towers along the mountains' crest, and the bright blue pillars of the Sandia Peak Tramway staggering up the mountains' steep western facade. At the mountains' base, in and around the foothills, are strung neighborhoods of streets and driveways and homes. These homes are in Albuquerque, and Albuquerque is in the mountains.

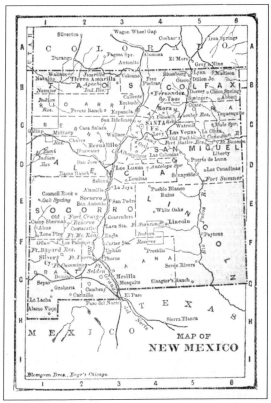

When Albuquerque was established in 1706, the Spanish spelled its name *Alburquerque*—after the Duke of Alburquerque, Spain. Over time in the 1800s, however, the name's first R was repeatedly and then permanently dropped by English-speaking newcomers. But the spelling on this New Mexico Territory map—included in the 1888 *Conklin's Handy Manual of Useful Information and World's Atlas*—was *never* right. (Courtesy Margaret Luellen Briggs and Mark Ramirez.)

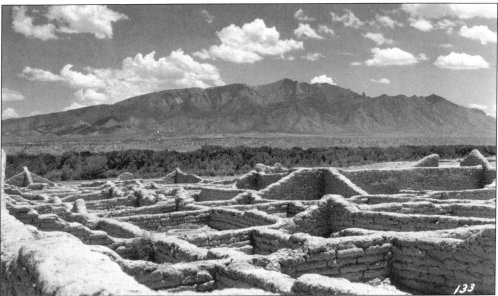

Albuquerque sits in the middle of what was once the Province of Tiguex—a 35-mile-long collection of Tiwa Indian villages. In the early 1540s, residents of these villages reluctantly provided clothing, food, and shelter for the troops of explorer Francisco Vásquez de Coronado, subsequently rebelled, and were killed by the hundred. This 1940s postcard shows one such village, Kuaua, ironically preserved as Coronado State Monument. (Courtesy Audrey and Orris Moseley.)

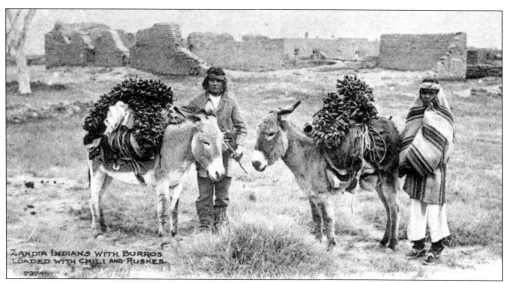

Also in the Province of Tiguex was a pueblo known as Nafiat, or "Place Where the Wind Blows Dust"—founded in the 1300s, renamed Sandia by Coronado in the early 1540s, and shown on this postcard c. 1906. In the 1600s, the Spanish forced residents of the pueblo to work mines and build churches, and in 1680 those residents helped force the Spanish out of New Mexico. (Courtesy Nancy Tucker.)

Caused by exposure to the microorganism *Mycobacterium tuberculosis*, tuberculosis is an extremely contagious, potentially fatal disease that most often affects the lungs. In the late 1800s and early 1900s, until a cure was developed in 1952, TB patients—a.k.a. "health-seekers" or "lungers"—came to Albuquerque by the hundreds, lured in part by the "Sunshine and Health" promised by promotional material like this 1930s booklet. (Courtesy Rick Holben.)

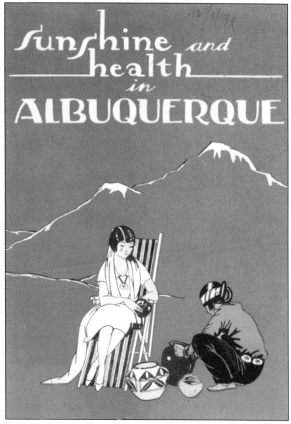

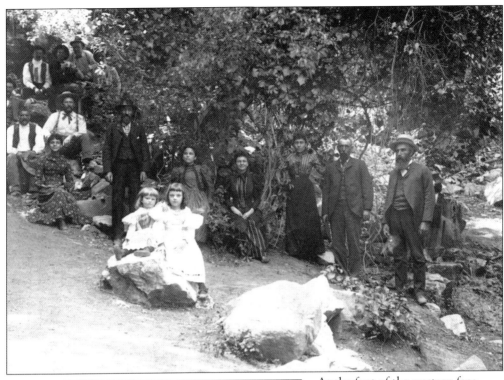

At the foot of the western face of the Sandia Mountains lies the 640-acre Elena Gallegos Picnic Ground—the last remnant of the 70,000-acre Elena Gallegos Grant. The grant's namesake, Elena Gallegos, moved back to New Mexico in 1692, the same year the Spanish re-conquered New Mexico's Pueblo Indians. Elena was the first female New Mexican with her own cattle brand and ran sheep and livestock on her vast desert tract. In the southernmost part of the Elena Gallegos Picnic Area lies Bear Canyon, a rock-studded, densely vegetated mountain defile, a place long visited by Albuquerque residents wanting to escape the city. The above photograph shows several Albuquerque citizens "picnicking at Bear Canyon," *c.* 1890. The postcard below shows a visit to that same canyon *c.* 1908. (Courtesy CSR, #000-119-0401, above; Nancy Tucker, below.)

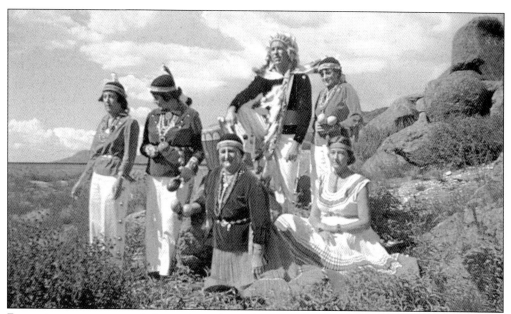

For various reasons, people have always been drawn to the Sandias. This early 1950s postcard shows perhaps the most bizarre of those reasons. Its back reads, "The Navajo Drill Team of the White Shrine of Jerusalem Albuquerque, New Mexico, is comprised of members who are interested in learning authentic Indian dances. Their goal is to present an outstanding performance at the Supreme Shrine Convention each year." (Courtesy Nancy Tucker.)

One of the most distinctive sights among the western foothills of the Sandias was the large white "U" painted on a sloping hill by students from Albuquerque's University of New Mexico. The U's white-painted rocks were allegedly turned over by aesthetically minded students in the 1960s, and the area is now a popular rock-climbing spot. This photograph shows the lettered foothill around the 1940s. (Courtesy Audrey and Orris Moseley.)

These penultimate four images all show the western face of the Sandia Mountains, much as the mountains have looked for millions of years. The first photograph was taken in 1891, the second and third sometime early in the first half of the 1900s, and the fourth *c.* 1930. In front of the Sandias in all of these pictures sprawls extensive desert grassland once known as El Llano—"the plain"—later known as the East Mesa, and currently known as the eastern half of Albuquerque, including the busy thoroughfares of Tramway, Juan Tabo, Eubank, and Wyoming Boulevards, shopping malls, strip malls, housing developments, schools, and golf courses. Only on the Sandia Indian Reservation, just north of Albuquerque, is the plain visible as it used to be. (Courtesy CSR, #000-119-0813, above; Nancy Tucker, below.)

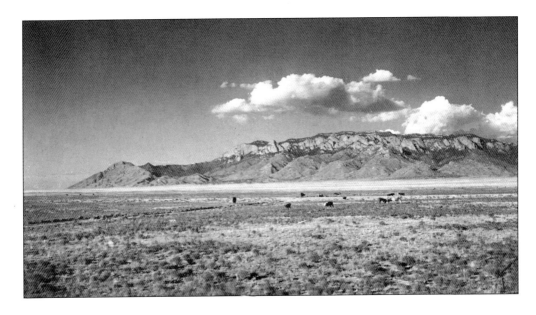

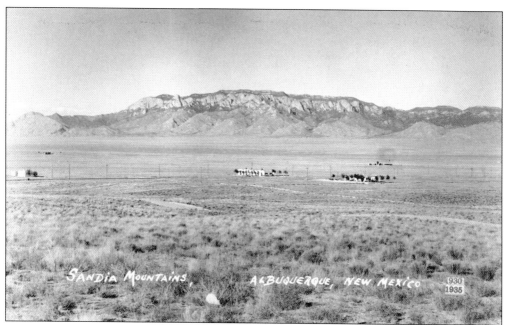

Albuquerque's East Mesa now barely resembles the open plain that cattle once grazed on, but the Sandia Mountains still stand above it. With almost 500,000 people currently living in the city of Albuquerque, it is probably not uncommon for many residents to treat the imposing Sandias as little more than scenery, as something to drive past on the way to work or to navigate by when heading east. Behind the mountains' granite countenance, however, are hidden all the towns and stories in this book, several towns not featured in this book, the sites of now vanished localities such as Kemp and Carpenter, the ruins of multiple Pueblo Indian villages, and more history than could ever fit into *any* book . . . or any library. (Courtesy NMSRCA, #33966, above; Audrey and Orris Moseley, below.)

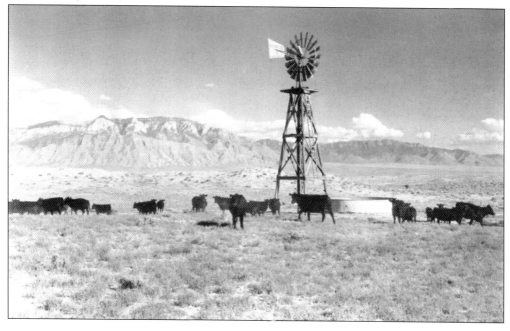

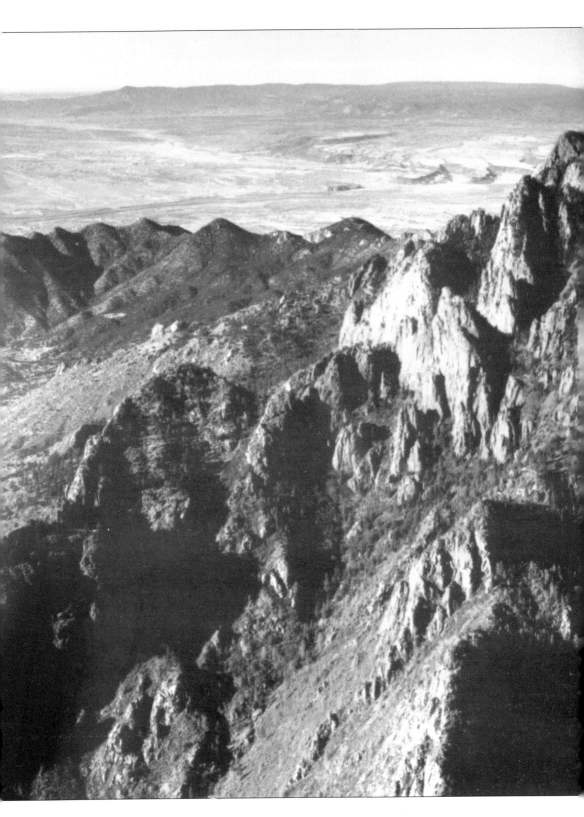

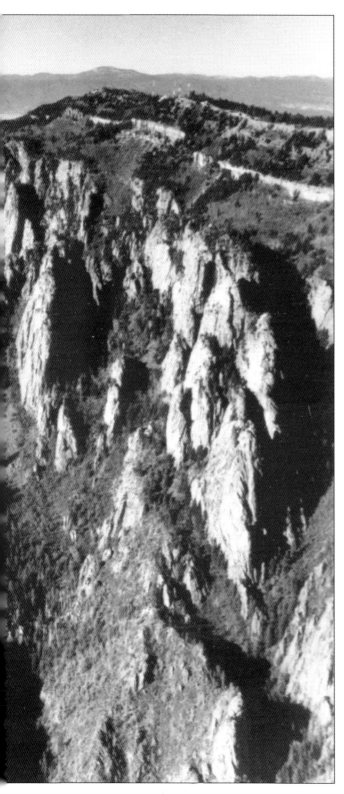

The entire history of mankind in the Sandias adds up to barely a moment in the mountains' overall life. The rocky uplift of the Sandia Mountains has stood through climate changes and extinctions, geologic upheavals, and nearby volcanic eruptions. These mountains have been home to mammoths and mastodons, grizzly bears and mountain lions. Much as the mountains are today, so they were when the first prehistoric men ventured into their canyons, when the first Spanish arrived at their feet, and when a great fire burnt down much of the mountains' trees around 1815. Much as the Sandias are today, and much as they were yesterday, so—most likely—will they be long after their towns have faded from the earth's surface . . . after even the mountains' name has been forgotten. (Courtesy NMSRCA, #33964.)

125

SELECTED BIBLIOGRAPHY

Alberts, Don E. *Rebels on the Rio Grande: The Civil War Journals of A.B. Peticolas*. Albuquerque: Merit Press, 1993.

Batchen, Lou Sage. *Las Placitas: Historical Facts and Legends*. Placitas, NM: Tumbleweed Press, 1972.

Children in All the Mountain Schools. *Fiestas in Our Mountain Villages*. Albuquerque: Albuquerque Public Schools, 1955.

Cordell, Linda S. *Tijeras Canyon: Analyses of the Past*. Albuquerque: The Maxwell Museum of Anthropology and the University of New Mexico Press, 1980.

Dart, Al, ed. *Archeological Investigations at San Antonio de Padua, LA 24, Bernalillo County, New Mexico*. Santa Fe, NM: Museum of New Mexico Laboratory of Anthropology, 1980.

Fairfield, Richard. *Communes USA: A Personal Tour*. Baltimore: Penguin Books, 1972.

Johnson, David R. *Conrad Richter: A Writer's Life*. University Park, PA: Pennsylvania State University Press, 2001.

Julyan, Robert. *The Place Names of New Mexico*. Albuquerque: University of New Mexico Press, 1996.

Julyan, Robert and Stuever, Mary. *Field Guide to the Sandia Mountains*. Albuquerque: University of New Mexico Press, 2005.

Morris, James A. *Oku Pin: The Sandia Mountains of New Mexico*. Albuquerque: Seven Goats Editions, 1980.

Salmon, Pamela. *Sandia Peak: A History of the Sandia Peak Tramway and Ski Area*. Albuquerque: Sandia Peak Ski & Tramway, 1998.

Schneider, Jill. *Route 66 Across New Mexico: A Wanderer's Guide*. Albuquerque: University of New Mexico Press, 1991.

Simmons, Marc. *Albuquerque: A Narrative History*. Albuquerque: University of New Mexico Press, 1982.

United States Forest Service and the New Mexico Museum of Natural History. *Sandia Crest National Scenic Byway*. Tijeras, NM: Friends of the Sandia Mountains, 1994.

Wilson, Chris. *Historic Resources Reconnaissance Survey of the Manzano and Sandia Mountain Villages*. Santa Fe, NM: State Historic Preservation Division Office of Cultural Affairs, 1994.

INDEX

ACROSS AMERICA, PEOPLE ARE DISCOVERING SOMETHING WONDERFUL. *THEIR HERITAGE.*

Arcadia Publishing is the leading local history publisher in the United States. With more than 3,000 titles in print and hundreds of new titles released every year, Arcadia has extensive specialized experience chronicling the history of communities and celebrating America's hidden stories, bringing to life the people, places, and events from the past. To discover the history of other communities across the nation, please visit:

www.arcadiapublishing.com

Customized search tools allow you to find regional history books about the town where you grew up, the cities where your friends and family live, the town where your parents met, or even that retirement spot you've been dreaming about.

MAP SEARCH